DONATELLO

DONATELLO

An Introduction

———— § ————

CHARLES AVERY

Principal Photographs by David Finn

IconEditions

An Imprint of HarperCollins*Publishers*

A hardcover edition of this book was published in 1994 by IconEditions, an imprint of HarperCollins Publishers.

HarperCollins books may be purchased for educational, business, or sales promotional use. For information please write: Special Markets Department, HarperCollins Publishers, Inc., 10 East 53rd Street, New York, NY 10022.

First paperback edition published 1995.

Designed by Abigail Sturges

The Library of Congress has catalogued the hardcover edition as follows:

Avery, Charles.
 Donatello : an introduction / by Charles Avery; principal
photographs by David Finn.
 p. cm.
 Includes bibliographical references and index.
 ISBN 0-06-430311-X
 1. Donatello, 1386?–1466—Criticism and interpretation.
I. Donatello, 1386?–1466. II. Title.
NB623.D7A9 1994 93-33467
730′.92—dc20

ISBN 0-06-430981-9 (pbk)
95 96 97 98 99 RRD 10 9 8 7 6 5 4 3 2 1

For
Charlotte, Susanna and Victoria

Contents

List of Illustrations

Color Plates
(following page 64)

DONATO SCVLTORE
FIORENT.

1. After Masaccio, *Portrait of Donatello,* 1568. Woodcut from Vasari's *Lives,* published in Florence, 1568

Introduction

———— § ————

DONATELLO was the greatest sculptor of the early Renaissance in Italy and one of the most versatile of all time, unmatched in his technical and expressive range. He carved marble both for large statues and for narrative reliefs, where he pioneered a very shallow degree of cutting [28–36]. He also worked in humbler sandstones, limestones and wood, which he sometimes painted and gilded [55; 79; Plate III]. He was famed for his drawings, though few examples have survived [81]. Expert at modeling wax and clay, either for preliminary sketches or for casting into bronze, he was a skillful metalworker and even experimented with sculpture in glass. He frequently painted his own statues and reliefs, some of which were cast in stucco. These media made different demands and permitted various solutions, with a great range of textures and colors [Plates I–IV].

Donatello was one of the key figures of the Renaissance, standing alongside Ghiberti, Masaccio, Uccello, Brunelleschi and Alberti. In fact, the only contemporary portrait is one showing several of them on a cassone front now in the Louvre, which are copied from a lost fresco by Masaccio. This was the source of the woodcut illustrated in Vasari's *Lives* [1]. Donatello was one of the pioneers of linear perspective; he was deeply concerned with the revival of Greco-Roman realism in art; and yet he was sincerely religious. His expressive portrayal of human character and relationships was noted in his own lifetime and makes his work particularly appealing today [Plate IV].

The sculptor was born in Florence, some six hundred years ago, in 1386, and he died in 1466, two years after his greatest patron, Cosimo de'

Medici. Thus he lived to be eighty—twice the normal life expectancy of the period—and he remained active almost till his dying day.

Donatello was as prolific as he was long-lived. We have detailed records of some thirty-five works—several of them whole complexes like the high altar for the Basilica of St. Anthony, Padua—and circumstantial evidence for a dozen more. However, there is no contemporary biography and the sculptor was ill served by the sixteenth-century art historian Vasari, whose account is very confusing and even inaccurate in places. There is no body of writings, like the *Commentaries* of his older colleague Ghiberti, and not a single line of personal correspondence, although one or two of his remarks—often disagreeable or sarcastic ones—were recorded by contemporaries.

In spite of this, we know a good deal about Donatello's career: between 1401 and 1461 there are four hundred references in Italian archives, some for nearly every year [see *Chronology,* p. 111]. These give a more detailed and continual record than we have for any other artist of the period. Even so, there are annoying gaps in our knowledge, notably the complete absence of documents or firm dates for the many major sculptures commissioned by the Medici. This may simply be due to the fact that certain of their meticulously kept account books are missing. However, another obvious explanation is that rich, private patrons—not only the Medici but others such as the Cavalcanti, the Strozzi, the Pazzi—would pay the artist from petty cash, or with wine, oil, corn or firewood from their estates, so that no record of the transaction was written down. Payment in kind was perfectly normal at this period and occasional gifts helped things along.

Donatello's Character

A CONTEMPORARY, Vespasiano de Bisticci, remarked upon a special relationship that existed between Cosimo de' Medici [85] and Donatello: "Cosimo," he wrote, "was a great expert on sculpture and much favored sculptors and all worthy artists. He was a great friend to Donatello. . . . Since Donatello did not dress as Cosimo would have liked him to, Cosimo gave him a red cloak with a hood, and a gown under the cloak, and dressed him all afresh. One morning of a feast day he sent it all to him to make him wear it. He did, once or twice, and then he put it aside and did not want to wear it any more, for it seemed too dandified for him."

Such familiarity between patron and artist was rare at the time and is a tribute to Cosimo's humanity and broad-mindedness. For while Cosimo was a wealthy merchant and banker with great political power, Donatello was from a humble, artisan background and he remained simple and unpretentious, despite a certain degree of success in the eyes of the world. The red cloak and hood were the equivalent of a city business suit today—quite inappropriate for a bohemian artist. Vespasiano's tale is borne out by a payment made in Pisa by the Medici bank to Donatello in 1425 for two pairs of shoes. They also bought him a boat: unfortunately its purpose was not specified. It might have been for crossing the river Arno, for ferrying marble or simply for fishing.

In 1428, on the twenty-third of December, the authorities of Prato cathedral sent Donatello a Christmas present of corn and firewood; while in 1434 a mutual friend advised them to send him some money to spend on a feast day, saying that Donatello was "the sort of man for whom any little snack is adequate and he is well-pleased to receive anything at all." Both these gifts were made to encourage the sculptor to bring to comple-

1

tion his long overdue work on the external pulpit in Prato, with its frieze of panels with cavorting children [50].

Vasari relates a story about Donatello's carelessness with money—or generosity, depending on how one looks at it: "He was most liberal, gracious, and courteous, and more careful for his friends than for himself; nor did he give thought to money, but kept his in a basket suspended by a cord from the ceiling, so that all his workmen and friends could take what they needed without saying a word to him." This was a sure recipe for financial insecurity. The story may be exaggerated, but, as we shall see, it accords with other contemporary statements about financial arrangements made by Cosimo de' Medici for his protégé.

Donatello was a popular figure in Florence, where eccentricity and irony are cherished to this day almost as greatly as in England. Surprisingly, he featured as a speaking character in a miracle play written during his lifetime. Also, Vasari records some sarcastic remarks made to fellow artists. For instance, when Uccello showed him a painstakingly finished fresco of *St. Thomas* over the gate of the market, Donatello pondered it and then said: "Oh, Paolo, now that the time has come to hide it from view, you have gone and unveiled it." Uccello was so distressed that he shut himself up from then on to study the art of perspective day and night, to the frustration of his wife, so the story goes. Of course it may be that these apparently hard-bitten remarks were meant more or less in jest, but in the case of Uccello they seem to have been taken seriously and caused distress. Despite this, Uccello named his son Donato, after Donatello.

Even when being charitable Donatello could not resist being ironic. Asked for alms by a beggar "for the love of God," he retorted: "Not for the love of God, but because you need them"; and yet his sculptures indicate that he was a profoundly religious man. Vasari told a story about a wooden *crucified Christ* that Donatello carved early in his career, which he showed to Brunelleschi [2]. The latter criticized it as looking like a peasant on a cross, and then—on being challenged by his disappointed friend to do a better one—went off and carved his own version. This Donatello grudgingly admired: "To you it has been granted to make Christs, but to me only peasants!"

In his tax return of 1427, when he was about forty, Donatello declared his eighty-year-old mother and a widowed sister as his only dependents; twenty or so years later, in 1449, he sent a present of ten ducats to his sister, from Padua, where he was working. Manetti, describing in his biography of Brunelleschi the joint excavations that he made with Dona-

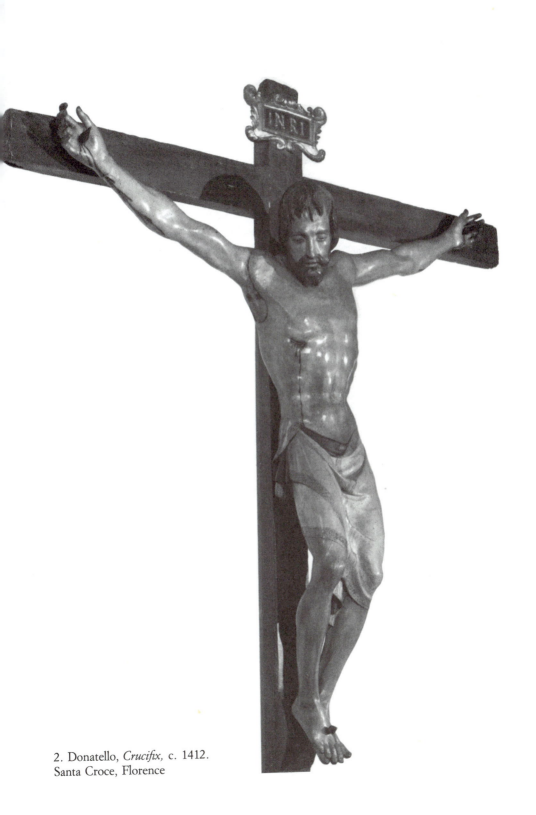

2. Donatello, *Crucifix,* c. 1412.
Santa Croce, Florence

tello in Rome during their youth, explained: "Neither of them had family problems since they had neither wife nor children, there or elsewhere. Neither of them paid much attention to what they ate and drank or how they were dressed or where they lived, as long as they were able to satisfy themselves by seeing and measuring." They were evidently some of the earliest bohemian artists, unlike for example the more bourgeois and respectable Lorenzo Ghiberti, a man whom neither of them cared for.

Donatello seems never to have married. Just as monks had to remain celibate, there was in the late Middle Ages a tradition of secular scholars remaining single, to dedicate themselves to their chosen pursuit. It may, therefore, have seemed natural to an artist to renounce marriage and family life in favor of his all-absorbing profession. Perhaps also his calling was too ill paid and insecure to support a family. There is however a suspicion that Donatello frequently became enamored of his studio boys, either models or apprentices. In the age of Neoplatonism, a broad and ennobling view of such affairs of the heart was entertained—unofficially of course. Platonic love is certainly one of the ingredients of the enigmatic bronze *David* and its sensual interpretation of male beauty, as it also probably was of the bust of a boy with a cameo around his neck [23; 73].

The only other evidence for his preference for male company is to be found in a collection of scurrilous tales compiled in the Medici circle about 1470 and published a century later, in 1548: Donatello liked having handsome assistants in his workshop, we are told. One came to him who was highly praised for his good looks. But the person who introduced him also showed him the youth's brother. Donatello admitted that the brother was ever handsomer than the boy who was seeking to enter his employment, but snapped: "He'll be all the less likely to stay with me." This became a catch phrase in Florence.

It should be borne in mind that there were no female models in those days. As in the theater, young boys acted the part of girls. So good looks in an assistant were an asset that any artist would have sought, whatever his sexual proclivities. Another of these tales is that Donatello tinted his assistants, in order that they should not be found pleasing by other people. Whether this simply means that Donatello tried to make his workmen look less healthy than they were, so that they would not be enticed away to other studios, is hard to decide. Even so, it sounds a decidedly bizarre way to counter industrial espionage!

That Donatello was physically rough at times is proven by the very first documentary reference we have, a legal report of 1401 about an attack

he made with a stick on a German youth in Pistoia, drawing blood. Whether this was merely teenage high spirits or the sign of fiery temper we cannot tell, but there are no further instances of personal violence. It is interesting to note that in this very year Brunelleschi was finishing off his figures for the silver altar in that city, and this may be why Donatello was there.

However, Vasari does relate a tale of violence to one of his own creations. Supposedly, he had cast a life-size bronze bust very lightly, so that its patron, a Genoese merchant, could transport it easily: the price had been agreed between them in advance. But when it was ready the merchant tried to browbeat Donatello into accepting a lower fee. In a fit of righteous indignation, the sculptor deliberately knocked the bust to the ground, telling the merchant that his penny-pinching showed he was more used to bargaining for beans than for statues. In fact the bust of *San Rossore* does have a hole in its head, covered with a lid, to give access to the skull relic inside [20]. A similar tale was in circulation that later in his career Donatello deliberately smashed the head of his equestrian portrait statue of Gattamelata, because he felt that his patrons were too demanding.

Whether these amusing tales are true or not, they may be interpreted as allegories of the way in which Donatello, in common with other artists of his day, was attempting to free himself from the humble status of an artisan, paid a daily wage, and to rise to that of an imaginative specialist, who could command a high fee based on the aesthetic and intellectual success of his work.

Donatello's character was posthumously—and perhaps charitably—summed up in a letter of 1525 from Pietro Summonte to Marcantonio Michiel: "In the days of our fathers there lived in Florence Donatello, a rare man who was rough and simple in everything but his sculpture, in which many believe that no one has been greater than he. He executed many unusual objects and, talented though he was in his art, he was just as amenable and quick in expediting his many works, which can be admired to this day in various places."

Actually, Donatello's relationships with some of his patrons became very strained: as early as 1415 he exceeded the contractual deadline on the *St. John;* about 1430 he irresponsibly absented himself for three years in Rome, when he should have been striving to complete the Prato pulpit; he was criticized for the lack of finish on the bronzes for the high altar in Padua in 1450; and he delivered his bronze *St. John the Baptist* to Siena cathedral in 1457 with its forearm missing, because he felt the payment

was inadequate. A year later he was said to be *molto intricato,* that is, "tricky" or "difficult," when Ludovico Gonzaga was desperately trying to get him to finish off some work he had promised. In fact, Cosimo de' Medici seems to have been the only man who could command Donatello's obedience [85].

These disagreements resulted not simply from a happy-go-lucky, bohemian attitude on the sculptor's part: there was an inherent conflict between the newfound individualism of the artist—in common with other thinking people—in the early Renaissance and a system of patronage that was still medieval in character, where the artist was no better than a craftsman who had to supply goods to order and on time. Donatello showed an understandable impatience with the committees of worthy burghers who administered the funds of the guilds or churches he had to deal with, and came to prefer the direct man-to-man relations he enjoyed with an interested individual patron like Cosimo de' Medici.

In fact, within Donatello's career one can chart a move away from the traditional, self-effacing, medieval pattern of corporate patronage toward one of individual commissions from private patrons which permitted greater scope for an artist's self-expression, in concert with the patron's own ideas.

Membership in a mercantile or professional guild was, of course, necessary to practice a craft or trade but also conferred the right to vote in Florentine politics. The guilds were responsible not only for their own premises and the central guild hall of Orsanmichele, but also—as a matter of civic responsibility—for key religious buildings: for instance, the Wool Merchants' Guild looked after the cathedral, while their great rivals the Cloth Finishers paid for the upkeep of the nearby baptistery. The direct comparisons between these edifices that could be made by passersby and foreign visitors as to their relative states of repair and decoration made for great rivalry. This stimulated the guilds and the artists whom they employed to vie with each other: one factor was the sheer cost of materials employed—for example a bronze statue cost about ten times as much as a marble one, while gilding was even more extravagant; another factor was the beauty or novelty of style. In the period under examination, this meant contrast between the ornate decorativeness which we now call International Gothic and the austere, but more gripping, realism of the new Renaissance mode, which was the avant-garde of the day.

Donatello's Early Career

———— § ————

THE most important commission for sculpture at the beginning of the century was a pair of bronze doors for the Baptistery in Florence. Their author, Ghiberti, having beaten Brunelleschi in the famous competition with his *Sacrifice of Isaac,* tended to remain an exponent of the Gothic, though he did introduce many borrowings from Roman sculpture. This was especially true on the second set of doors that he began in 1425—the *Gates of Paradise,* as Michelangelo was to call them.

Donatello first appears among the team of assistants helping Lorenzo Ghiberti with the production of the models and bronze reliefs for his first doors of the Baptistery (1404–1407). He was thus trained in the late Gothic style (with a few hints of the Renaissance) under the aegis of the greatest modeler and bronze foundryman of the day. From him Donatello would have learned to model figures convincingly in relief against a flat background. Vasari also recorded some decorations in the old town house of the Medici: "Donatello, then quite young, made with stucco, gesso, glue and pounded brick, some stories and ornaments in low relief, which, being afterwards overlaid with gold, made a beautiful accompaniment for the painted stories." In 1407, however, Donatello, by now twenty years old, started to carve marble statuary on his own account for the Board of Works of Florence Cathedral, and this would have been paid for by the Wool Merchants Guild. He must have served an apprenticeship in marble carving before joining Ghiberti's team in 1404, for it was a skill that he could not have learned from a goldsmith. However, the style of his earliest statues is still very like Ghiberti's. It was probably at this time that he and Brunelleschi carved their wooden crucifixes in an informal competition with each other [2].

Starting with two small prophets for an elaborate door on the north

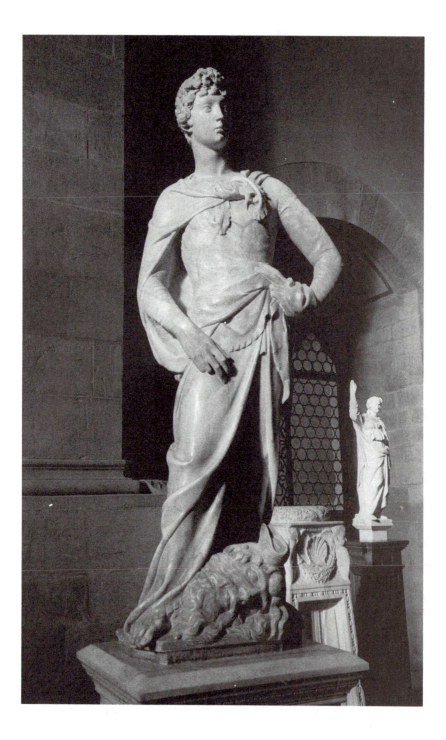

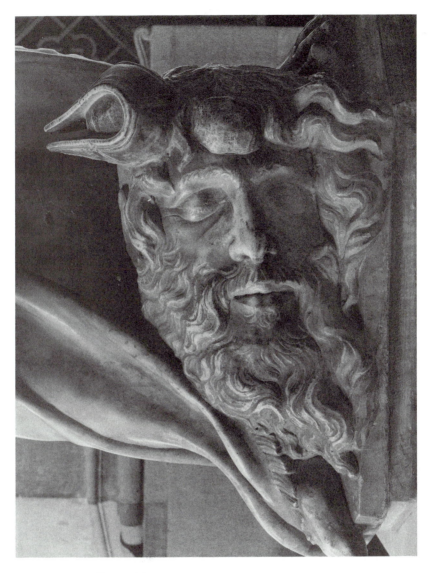

3. (*Left*) Donatello, *David,* 1408–1412.
Museo Nazionale del Bargello, Florence

4. (*Above*) Donatello, *David*. Detail of Goliath's head

side of the Cathedral, he shortly afterward began a life-size marble statue of *David* for one of the buttresses. Such a prominent commission would not have been given to a mere beginner. The statue was judged too small for this position, and so it was acquired by the city council in 1416 for symbolic display in the town hall—the Palazzo della Signoria. This is a sign of Donatello's growing renown. The figure was elaborately painted and gilded and installed there on a base inlaid with colored glass mosaic. The statue has unfortunately been removed long since to the Museo Nazionale del Bargello and has lost its costly ornaments [3]. They would have made it look far less bland than it does today and would have related it better to the ornamental style—now called International Gothic—which was much in vogue at the time. It would have resembled the young king in Gentile da Fabriano's *Adoration of the Magi* in the Uffizi Gallery. The swaying elegance and sinuous play of folds are exactly like the contemporary designs of Ghiberti: but Donatello's preoccupation with elegance diminishes the drama of David's astounding victory over Goliath. There is no psychological link between the boy and the victim at his feet: this would be uncharacteristic of the mature Donatello. The only trace of Renaissance realism is the forceful modeling, portraitlike detailing and vigorous carving of the head of Goliath [4]. These were not to be outdone when he returned to the theme much later in his career with a bronze version [75].

With his next commission from the Board of Works, *St. John the Evangelist,* Donatello moved to center stage, for he was one of three leading sculptors to be commissioned to carve four colossal statues of *Evangelists* to flank the great west doors. The significance of such statues in public life was greater than we find easy to appreciate today, when the power of sculpted images has been lost to the immediacy of the photograph or motion picture. It is no coincidence however that a miniaturist included two of the series—one of them Donatello's statue—in an illumination showing the reception of Pope Eugenius IV at Florence cathedral in 1439 (when the Ecumenical Council moved from plague-stricken Ferrara to Florence at the behest of the Medici). Physically set above the heads of the bystanders, the statues seem to hover in mediation between the heavenly realm and the laymen of Florence, the College of Cardinals and the Holy Father below.

The majestic, seven-foot-high *St. John* took some six years to execute, partly owing to other commissions [5; 6]. The symbolic beasts normally used to distinguish the Evangelists were abandoned, presumably in the interests of realism. Instead, Donatello concentrated our attention on the

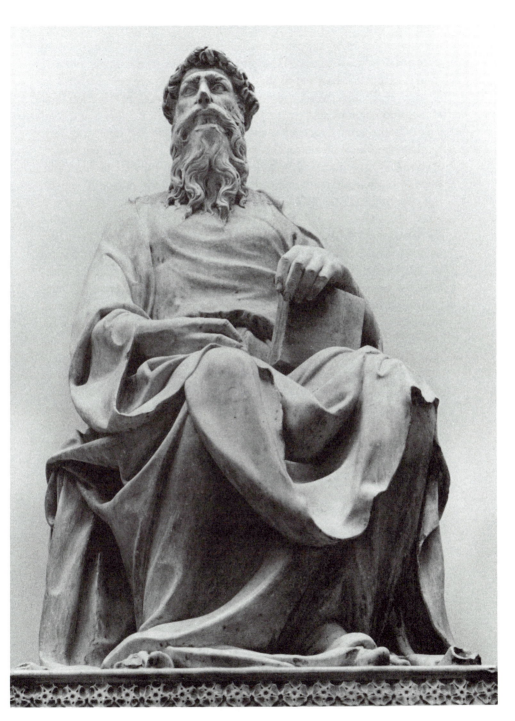

5. Donatello, *St. John the Evangelist,* 1408–1415.
Museo dell' Opera del Duomo, Florence

head and the hands. Here he pioneered the new style of maximum realism, derived from a reassessment of classical remains: this is apparent not only in the heads, expressions and poses he adopted from Roman portrait statues and busts, but also in the disposition and groupings of figures in his narrative reliefs, which are indebted to Roman sarcophagi, triumphal arches and columns such as Trajan's.

When commissioned soon afterward, in 1411, by the Linen Drapers' Guild, to produce for their niche on Orsanmichele a statue of their patron *St. Mark* [9], another Evangelist, Donatello again omitted his symbolic beast, the winged lion, for it was depicted below on the ledge of the niche but gave his head a positively leonine look with heavy brow, wide nose and a veritable mane of hair [7]. It begs comparison with the heraldic lion of Florence, the *Marzocco,* that he was called upon to carve in 1418 [10]. Conversely, the head of this lion is appealing to us precisely because it is so anthropomorphic [8]. These effects are not casual or humorous, but reflect contemporary concern with interpreting physiognomy and character in humans by reference to the animal world. Michelangelo is reported to have said that he had never seen anyone who looked more like an honest man than Donatello's figure, and that if St. Mark resembled this statue, his gospel should be believed!

The ponderation of Donatello's *St. Mark,* which makes it look so authoritative, is derived from Roman statues of senators: a clear differentiation is made between the weight-bearing leg, clad in vertical folds like the flutes on a classical column, and the relaxed leg, whose knee projects through the curving planes of drapery opposite. Donatello resorted to a rather peculiar device in making the saint stand on a cushion. This must have been an allusion to products of the textile guild that paid for it, but its rationale from the sculptor's point of view is that it allowed him to suggest the physical weight of the figure by the indentation that the feet make on the yielding material of the cushion. The figure really seems to stand.

Donatello received his next commission for a patron saint for a niche on Orsanmichele from the Guild of Armorers [11]. It was to represent *St. George,* a knight in armor and thus an advertisement for their wares while swords and breastplates were displayed on the coats of arms of the guild at either end of the niche below! He also held in his lowered right hand a sword, probably made in gilded bronze, which projected outward from the niche above the heads of passersby, almost like a shop sign [13]. This was a bold touch of realism that served to relate the everyday world of the layman in the life below to the realm of the saint above. We have always

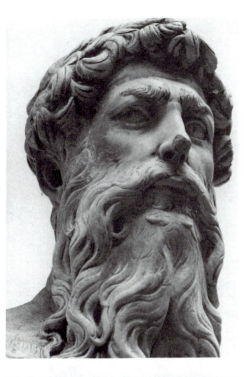

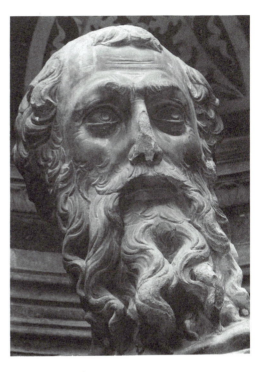

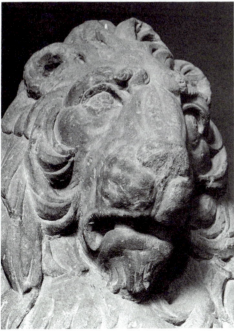

6. (*Above left*) Donatello, *St. John the Evangelist.* Detail of the head

7. (*Above right*) Donatello, *St. Mark.* Detail of the head

8. (*Left*) Donatello, *The Marzocco.* Detail of the head

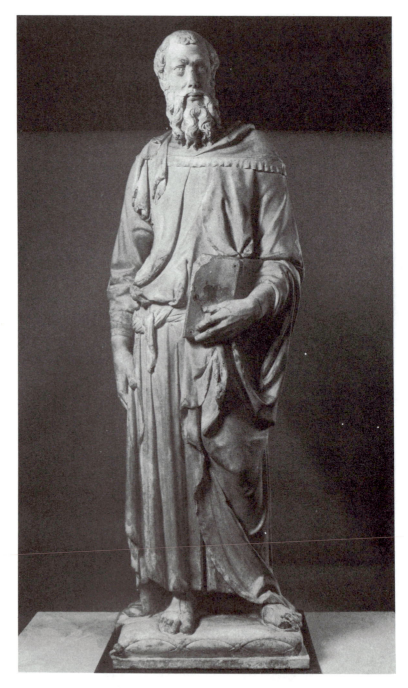

9. Donatello, *St. Mark,* 1411–1413. Orsanmichele, Florence

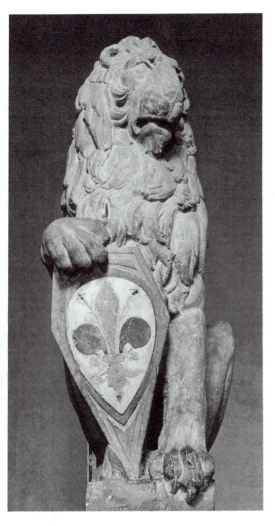

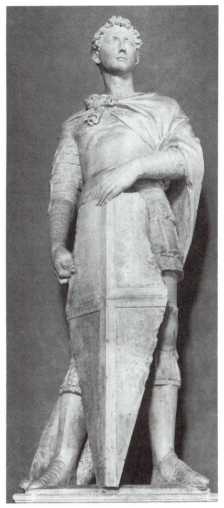

10. Donatello, *The Marzocco* (heraldic lion of the City of Florence), 1418–1420. Museo Nazionale del Bargello, Florence

11. Donatello, *St. George,* c. 1415–1417. Museo Nazionale del Bargello, Florence

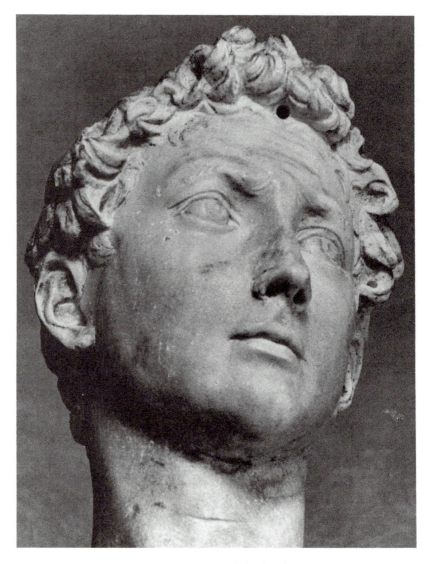

12. (*Above*) Donatello, *St. George*. Detail of the head

13. (*Right*) Donatello, *St. George*. Detail of the right hand

to bear in mind that such a statue was a religious image, not a "work of art" in our sense of the word. In the Catholic faith, the saints play a vital role as intermediaries between the mortal and the divine, so that they are not regarded as quaint or remote mythical figures, but as models for human behavior and the chief hope of salvation.

Even if it was a good advertisement for his patrons, the suit of armor in which Donatello had to clothe the figure provided an obstacle to expressiveness, for metal—being unyielding—is quite characterless. Nevertheless, it served to concentrate the spectator's attention on the pose, the face [12] and the hands. Donatello was able so admirably to convey the feeling of tension, anticipation and courage that the statue has always been a favorite. "For the Guild of Armorers," wrote Vasari, "he made a most spirited figure of St. George in armor, in the head there may be seen the beauty of youth, courage and valor in arms, and a proud and terrible ardor; and there is a marvelous suggestion of life bursting out of the stone."

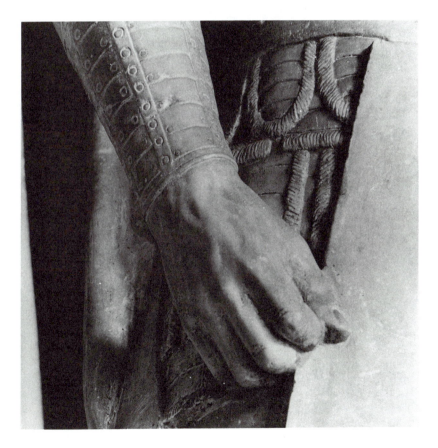

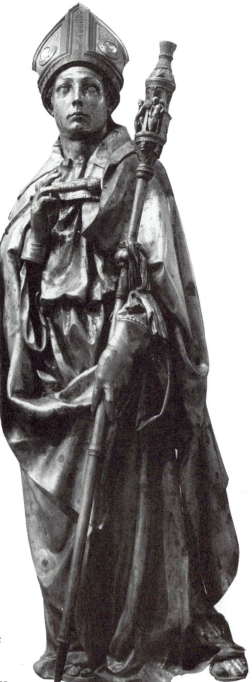

14. Donatello, *St. Louis
of Toulouse,* c. 1423.
Museo dell' Opera
di Santa Croce, Florence

15. Copies of Donatello's statues of prophets. Campanile, Cathedral of Florence

Donatello's last contribution to the sculpture on Orsanmichele was under the aegis not of a guild, but of the dominant political party, the Guelphs. They were evidently determined to outdo all their rivals by having Donatello use bronze and then gild their *St. Louis of Toulouse* [14; 44]: this was a highly extravagant procedure. For this complex technical challenge, Donatello seems to have tempted away from Ghiberti an experienced metallurgist, Michelozzo, who had recently helped him on a bronze *St. Matthew* also for Orsanmichele. From about 1424 to about 1433 Michelozzo and Donatello were business partners, forming a company and jointly producing several great sculptural and architectural works.

The technique of fire-gilding, which necessitated refiring the cast bronze in order to fuse gold leaf to its surface with a mercury amalgam, meant that Donatello had to make the figure in sections small enough to go into the size of kiln available: an illusion of a figure had to be built up from a number of preshaped segments of bronze drapery secured to an iron armature inside. This process may have been suggested by the suit of real armor he must have used as a model for his *St. George*. Technical necessity thus directed Donatello's imagination to the use of drapery itself

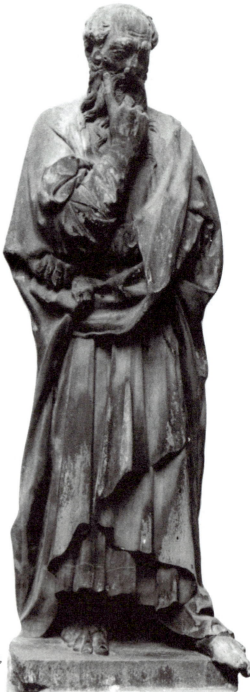

16. Donatello, *Bearded Prophet,*
c. 1415–1420. Museo dell'
Opera del Duomo, Florence

as an expressive motif. The crinkly folds of the cope are suggestive of the stiffness of a material heavily embroidered with gold thread, as was customary at the time for ecclesiastical vestments. So fascinated did Donatello become with drapery which seems to have a life of its own that he adopted the same deeply modeled indentations for one of the marble statues of prophets for the bell tower of Florence cathedral (his next commission), where it was not demanded by any technical considerations [16].

Indeed, after he had finished his two statues in marble for the guildhall, it was to the empty, Gothic niches high up on the famous Campanile of Giotto that Donatello turned his attention. In this ambiente his efforts were rewarded by the Wool Merchants' Guild, who were responsible for funding the cathedral, and were great rivals of the Cloth Merchants' Guild, who sponsored Ghiberti's efforts on the baptistery.

Between 1416 and 1423, Donatello produced for them four or more life-size marble statues of Old Testament prophets. The copies that now replace them indicate the range over which the sculptor had to make his figures tell on the passerby: their gestures had to be distinct and their faces legible from a hundred or so feet below [15]. Here the sharp light of Tuscany came to his aid. When viewed from close to, in the confines of the Museo dell' Opera del Duomo, in a way that the sculptor never intended, they make a truly alarming impression, so intensely melancholy are their wizened, stubbly faces and so nervously strained their starving bodies, angularly set limbs and large, coarse hands [17; 18].

Familiar as he was to become with the mightiest in the land—Cosimo de' Medici and his peers—Donatello nevertheless hated pretentiousness or exaggeration and was prone to reduce life to its bare essentials and to depict human emotions at their most basic and universal. These hard-bitten, emaciated types Donatello observed among his fellow Tuscans, be they patricians or soldiers, churchmen or merchants, artisans or peasants. But in his carvings Donatello ennobled them through his depth of feeling for mankind and his understanding of human sufferings and aspirations.

As early as 1456 Bartolomeo Facio wrote in *Illustrious Men:* "Donatello excells for his talent and no less for his technique; he is very well known for his bronze and marble figures, for he can make people's faces come to life, and in this he comes close to the glory of the ancient masters." Never had such convincingly modeled and characterized faces been seen before; the ancient Roman portraits from which the facial types were initially derived are normally rather lacking in emotion, being based on death masks, a part of Roman religious ritual.

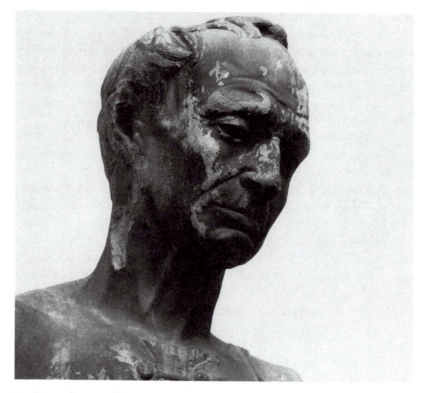

17. Donatello, *Beardless Prophet.* Detail of the head.
Museo dell' Opera del Duomo, Florence

Contemporaries believed that the statues were portraits of identifiable, living Florentines. This is by no means out of the question, but we have no independent portraits of any of the prominent citizens named, so we cannot check the likenesses. The mere fact that the statues could be thought of as portraits is an indication of how amazingly real they appeared to Donatello's contemporaries. They seem so even to us, with our eyes jaundiced by five hundred years of subsequent realistic portraiture against which to compare them.

While Donatello was carving the last prophet, the bald *Habbakuk,* Vasari relates how the sculpture would stare at him and growl "Speak, speak or may you shit blood." Possibly it was the search for ever deeper emotional effect that caused Donatello such agonies and contributed to the length of time it took to carve: 1427–1435 [19]. However, after his efforts were successful in achieving a deeply moving likeness of a venerable

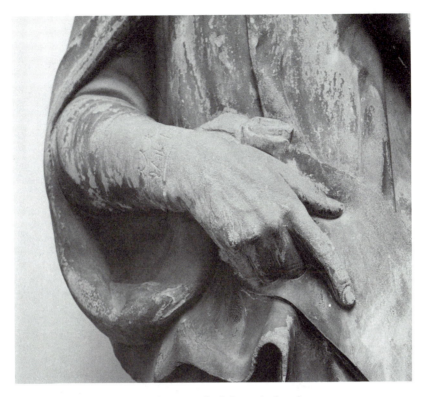

18. Donatello, *Beardless Prophet.* Detail of the right hand

prophet, the sculptor's attitude to his creation warmed and he used to swear: "By the faith that I place in my 'old baldy.'"

Donatello's interest in ancient Roman portraiture evinced in the heads of his prophets is confirmed by the existence of three portraits, either imaginary or real, for which he used the form of the bust. The earliest—and the only one that is documented and can be dated to within a span of five years (1422–1427)—is the gilt-bronze *San Rossore,* which he fashioned for the monks of the church of Ognissanti in Florence [20]. A bust was the traditional shape of the container for relics of saints' heads and had served to perpetuate the classical type throughout the Middle Ages. Such reliquary busts were often wrought in silver and gold and ornamented with gems from antiquity or precious stones. Normally, however, their appearance was purely symbolic, with a bare minimum of

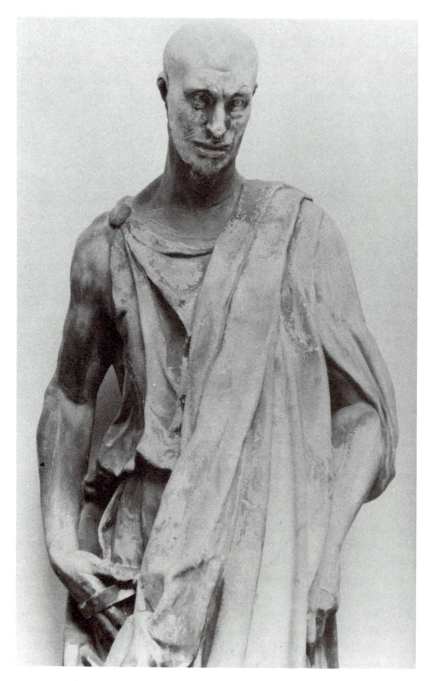

19. Donatello, *Habbakuk,* c. 1427–1435. Detail of the upper body.
Museo dell' Opera del Duomo, Florence

attributes—such as a miter if the saint were a bishop—to identify the subject. Donatello shattered this tradition by endowing the head of his San Rossore with deeply pensive, portraitlike features. The saint was a Roman soldier converted to Christianity, who had been beheaded under Diocletian. Of course the sculptor had no likeness to go on and had to summon up from his imagination the resolute yet soulful features that would be appropriate to a military martyr whose bravery had led him to execution at the hands of his own men. While the physiognomic structure and detailing recall a Roman ancestor bust, the introspective gaze could have been studied from life. The knitted brows, large, staring eyes, straight nose, high cheekbones with sunken cheeks and the large mouth set firmly between mustache and beard all recall Donatello's own facial features [21]. Masaccio's lost fresco of the *Assumption* in the *Sagra* of the church of Santa Maria del Carmine, which included Donatello's portrait among many other contemporaries as spectators of the miracle, dated from precisely the period of this bronze bust. Romantic as such a hypothesis may seem, it would be an obvious expedient for the artist to adopt, when faced with portraying a long defunct human being. Artists are often intrigued with their own appearances (for example, Albrecht Dürer), and it was quite customary in the early fifteenth century for them to feature as a bystander, alongside their patrons, in their own works. This is one sign of the new interest in the individual, which is characteristic of the Renaissance. One might also recall how Bernini two centuries later was to use expressions copied from his own face grimacing in a mirror for his *Damned Soul* and his *David*. Even if the head of San Rossore is not an idealized self-portrait, it is so specific in detail that one is justified in regarding it as the earliest revival of the classical type of portrait bust in the Renaissance. The sculptor seems to have recalled his treatment of the tousled, close-cropped hair and gaunt face of a man of action when, much later in his career, he was called upon to portray a contemporary general, Erasmo da Narni [56].

The second portrait bust with which Donatello's name has been associated is one thought to depict a Florentine patrician, Niccolò da Uzzano (1359–1433) [22]. The identification of the bust hinges on its similarity to some painted likenesses and to a profile portrait of Niccolò on a posthumous medal of later in the century. The differences in scale, medium and date notwithstanding, there seems to be a distinct resemblance and so the bust probably does show Niccolò. Leader of a political group, the *Ottimati* (Optimates), Niccolò was a prominent patron of the arts in both public and private, alongside the Medici and the Strozzi. He was one of the four executors of the will of John XXIII, and it may have

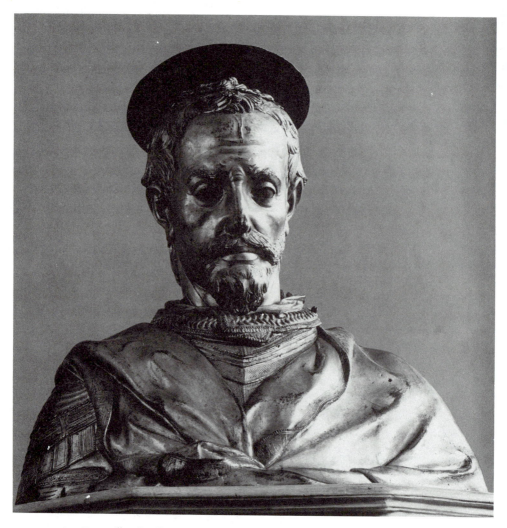

20. Donatello, *San Rossore,* c. 1427.
Museo Nazionale di San Matteo, Pisa

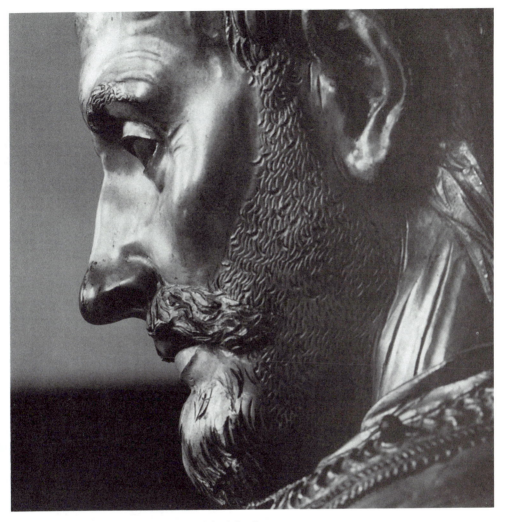

21. Donatello, *San Rossore.* Detail of the face

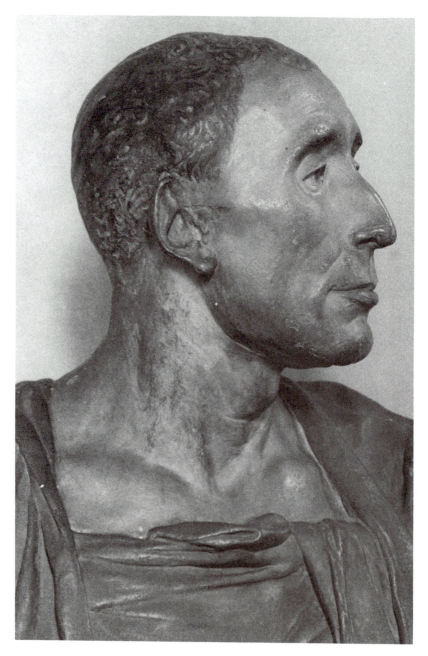

22. Donatello, *Niccolò da Uzzano,* c. 1430.
Museo Nazionale del Bargello, Florence

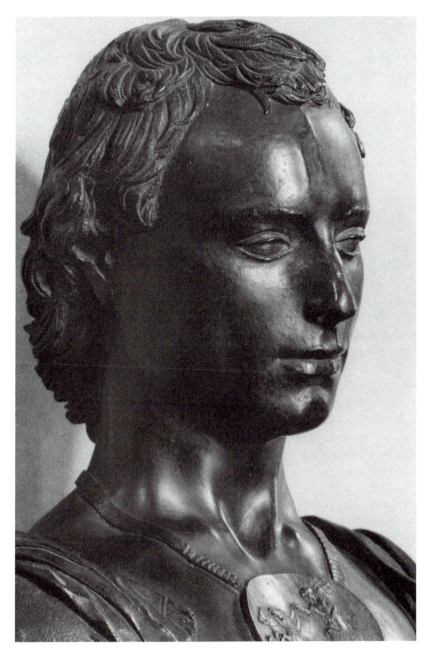

23. Donatello, *Bust of a youth wearing a cameo,* c. 1435? Detail.
Museo Nazionale del Bargello, Florence

been in this connection that Donatello came to know him. The sitter's apparent age is also consistent with the period of Niccolò's known contact with the sculptor early in the 1420s, when he would have been just over sixty. His emaciated features, which give a careworn expression, were captured with the help of a face mask, a technique in use since at least the date of the treatise of Cennino Cennini, in which it is described.

Donatello's contact with a painter of the eminence of Masaccio at just this period, which will be remarked in connection with his reliefs of the Madonna and Child, probably encouraged him to embark on the experiment of painting the bust to increase its verisimilitude. When first unveiled, it must have seemed the ultimate in realism.

The third bust with which Donatello's name is usually associated shows an idealized youth, wearing around his neck a cameo once owned by the Medici. Cast in bronze, it resembles in facture, style and apparently Neoplatonic imagery Donatello's bronze *David* and was probably produced in the Medici circle at much the same date [23]. Given that the features of a teenage boy are not normally ravaged by the effects of time or worry, the bust could easily be a real portrait; a side view reveals a slightly aquiline nose and does not conform to the straight Grecian profile that might be expected in an ideal work.

With these portraits, be they real or imaginary, Donatello revived a whole class of Roman sculpture single-handed and, it appears, relatively early in the Renaissance. He never carved a bust in marble, however, and this was left for his successors in the middle of the century: Mino da Fiesole, whose bust of Piero de' Medici is the earliest such bust to bear a date—1453; and Antonio Rossellino, who portrayed Donatello's doctor, Giovanni Chellini, in this way in 1456 [68]; while their gifted contemporary Desiderio da Settignano preferred to depict women and little boys, rather than men.

The Shallow Relief Carvings
1417–1433

———— § ————

U NTIL the mid-1420s Donatello had been employed almost exclusively by public bodies. By then, however, his fame was established and a number of private patrons began to offer him and his partner, Michelozzo, big commissions. Most prestigious of these was a tomb to be erected in the Baptistery to the antipope John XXIII [24]. He had been deposed as a result of the Council of Constance in 1415 and had subsequently been accommodated by the Medici, who were personal friends and supporters of his claim to the papacy. He died penniless in 1419 and it was left to his four executors (among whom were Giovanni di Bicci de' Medici and Niccolò da Uzzano) to arrange for a tomb and to raise the necessary funds. There was much controversy over the location and nature of the monument, but finally the executors had their way. The tomb was cleverly designed to fit between two of the ancient Roman columns that had been incorporated into the fabric of the Baptistery. By the date of the tax returns made out in 1427, the partners had spent three-quarters of the money allocated for the papal tomb and so work was probably nearing completion. Donatello's hand is discernible only in the gilt bronze effigy of the deceased with its expressive portrait head [25].

By 1427 the partners had also begun other tombs, all in marble, for clients in Montepulciano and as far afield as Naples. Again, Donatello made no palpable contribution to either except, presumably, in the design stage and in the *Assumption of the Virgin* for the Neapolitan tomb, a relief that he carved entirely by himself [26]. We can identify his hand readily in this panel, for the design is virtually drawn into the surface of the marble with the corner of a chisel: this novel technique—known in Italian as "ironed-out relief" (*rilievo schiacciato*)—was a personal invention of Donatello and represents a departure from classical and medieval practice. For

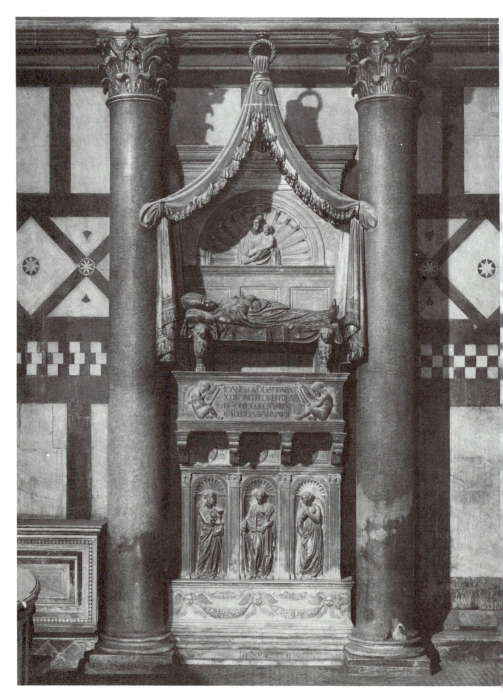

24. Donatello and Michelozzo, *Tomb of the Antipope John XXIII,* c. 1421–1428.
Baptistery of San Giovanni, Florence

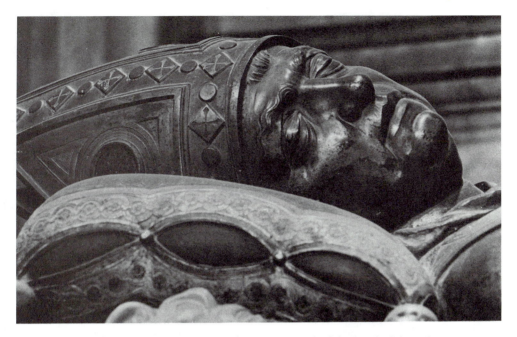

25. Donatello, *Tomb of the Antipope John XXIII.* Detail of the head of the effigy

in all earlier workshops the sculptor would chisel and drill down through the marble, round the contours of the foreground figures (or other features) until they stood out from the flat background, half or more in the round. This was the system used by Nanni di Banco in his relief *Sculptors at Work* [27]. Donatello in *St. George and the Dragon* [28], which happens to be the earliest datable example of the technique (the marble lintel on which it was carved at the foot of the niche for his *St. George* on Orsanmichele was delivered in 1417), sketched the figures in only lightly, carving away very little marble from the original surface of the block until he reached the landscape background: at the right is an arcade projected in almost correct perspective to begin the illusion of depths, while beyond— and implicitly much farther away—is a row of stunted trees on hilltops. Their diminishing sizes and clarity suggest an effect of ever greater distance from the spectator. In the Naples *Assumption* of a decade later, Donatello dispensed with all geometric devices to indicate depths and showed the Virgin being borne up to heaven by a host of angels in an aureole of suffused light. Donatello lets the various levels of his picture find themselves, as he draws into the slab of marble with his chisels: he has only to scrape away a few fractions of an inch here or there to indicate a much greater distance in the imagined scene.

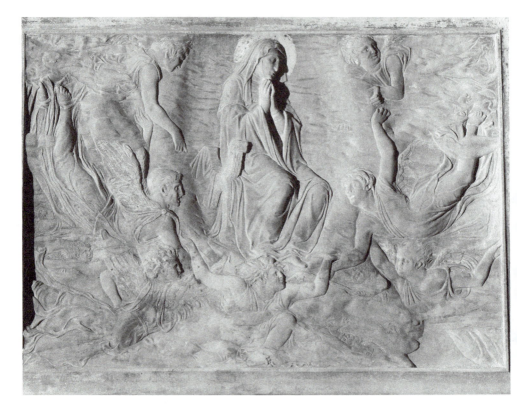

26. Donatello, *The Assumption of the Virgin,* c. 1427–1428.
Detail from the tomb of Cardinal Raimondo Brancacci.
Sant' Angelo a Nilo, Naples

27. (*Top right*) Nanni di Banco, *Sculptors at Work,* c. 1408–1413.
Orsanmichele, Florence

28. (*Bottom right*) Donatello, *St. George and the Dragon,* 1417.
Museo Nazionale del Bargello, Florence

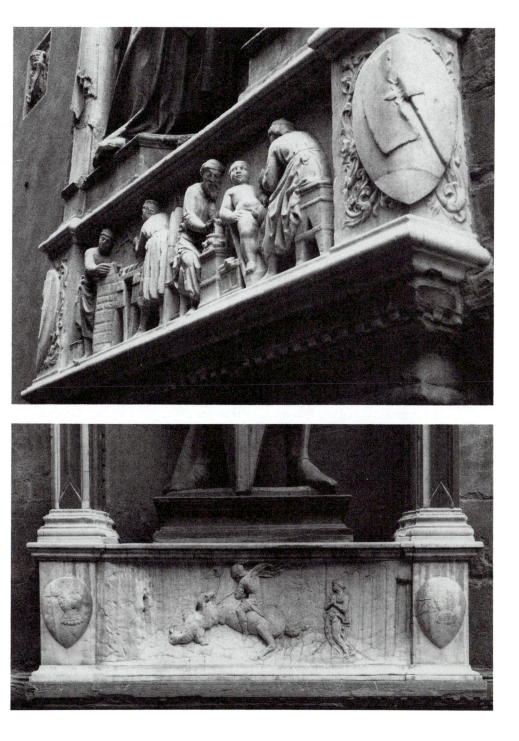

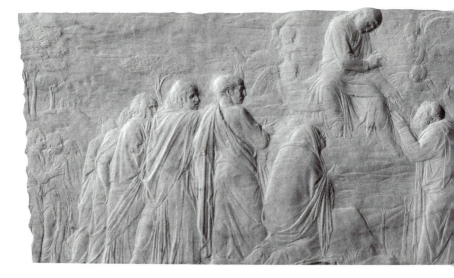

The classic example of this type of shallow relief is the *Ascension of Christ and the Giving of the Keys to St. Peter* [29]. This was recorded in 1492—in the same finely carved walnut frame as we see it today—in the collection of the Medici, and they may have commissioned it. Another theory is that they acquired it only in the 1430s from the Brancacci, who had intended it as a predella panel on the altar of their family chapel in the church of the Carmine, amid the celebrated frescoes of Masaccio and Masolino. In any case, there are close analogies between Donatello's scene and *Christ and the Tribute Money* painted by Masaccio. We know that the sculptor and painter were in touch with each other several times during 1426, when both were temporarily working in Pisa. Incidentally, Donatello himself is said to be portrayed, in the guise of a bearded beggar, in the adjacent fresco to the right showing St. Peter giving Alms. Sculptor and painter both succeeded admirably in placing their groups of Christ and his disciples convincingly in a setting of open landscape, without geometric aids.

In the marble relief Donatello combines two quite distinct episodes from the New Testament: Christ conferring the leadership of the church on St. Peter; and his Ascension, which occurred after his death and Resurrection. The first of course also represented the foundation of the papacy and this, together with the low viewpoint from which the sculptor evidently intended the relief to be seen, suggests that it may possibly have been intended to be set on the front of the sarcophagus in the Baptistery

29. (*Left*) Donatello, *The Ascension of Christ and the Giving of the Keys to St. Peter,* c. 1425–1430. Victoria and Albert Museum, London

30. (*Below*) Donatello, *The Ascension of Christ and the Giving of the Keys to St. Peter.* Detail showing the Virgin Mary, Christ and St. Peter

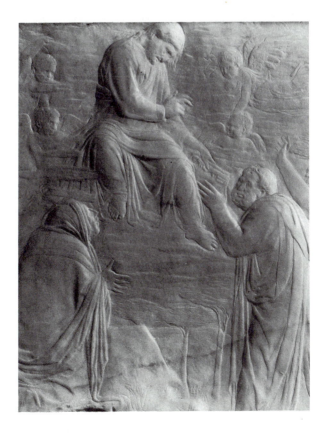

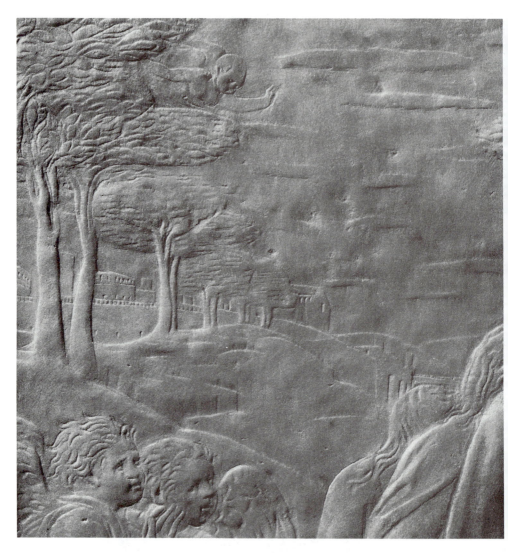

31. Donatello, *The Ascension of Christ and the Giving of the Keys to St. Peter.*
Detail of landscape at left of panel

of the antipope John XXIII, which is high above the spectator's head. It would then have had a position analogous with *Assumption,* the relief on the tomb in Naples. Medicean sponsorship of the tomb has already been suggested, and we know that John XXIII's claim to the papacy was supported by Giovanni di Bicci and Cosimo. There was considerable dissension over the wording of the inscription that is now on the sarcophagus and it may be that the present relief had to be suppressed owing to opposition within Florence from the supporters of Pope Martin V.

Donatello imagined a personality and a vivid reaction for each of the disciples witnessing the miraculous event [30]. St. Peter's face is based on the standard image of the saint, shown for example in Arnolfo di Cambio's bronze seated statue in the basilica in Rome. The Virgin Mary is the most daring figure: she is shown not young and unblemished by time as was conventional, but as a haggard old peasant woman, kneeling on the ground with her humped back toward us, her bony face just visible in profile and her hands spread out almost like claws, to indicate her amazement. The two half circles of disciples mustered on each side of the central trio are treated as interreacting groups, rather than as individuals. The scene is framed within an open landscape with rows of hills and trees leading the eye back into a pretended distance, the haziness of which is rendered by the refraction of light from the crystals of the marble [31]. The surfaces are left rough-cut and chiselmarks are clearly to be seen, which suggests great spontaneity and vigor in carving. Clearly the sculptor intended this lack of polish and of a medieval craftsman's finesse to suggest movement and drama in a way that had never been done before and has scarcely ever been equaled since.

About 1425 Donatello contributed a gilt-bronze relief of the *Feast of Herod* to the font in the Baptistery at Siena (a complex designed and partly executed by the local sculptor Jacopo della Quercia and to which Ghiberti also contributed) [40; Plate I]. Here he continued the experiments with architectural settings that he had begun with the arcade in the relief of St. George. The relief, which is exactly square, shows a close-up view inside Herod's palace. It is constructed in ashlar masonry with arches and divisions in the classical style, which must have been inspired by Donatello's study with Brunelleschi of ancient architecture in Rome: for, as Manetti relates, "together they made rough drawings of almost all the buildings in Rome and in many places beyond the walls, with measurements of the widths and heights as far as they were able and also the lengths. In many places they had excavations made in order to see the junctures of the

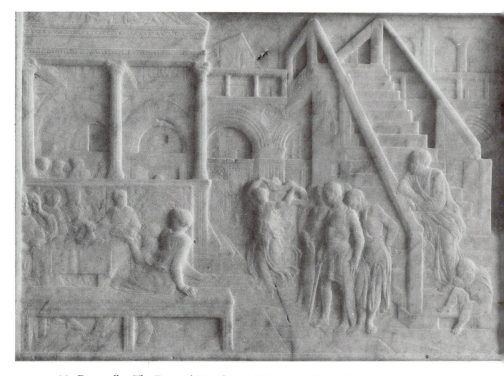

32. Donatello, *The Feast of Herod,* c. 1425–1435. Musée des Beaux-Arts, Lille

membering of the buildings and their type—whether square, polygonal, completely round, oval or whatever."

This methodical study enabled Donatello to reconstruct an ancient palace interior very convincingly and of course it gave an historically accurate setting, for the events he had to depict took place in the days of the Roman Empire. From the spiral narrative relief on Trajan's column, Donatello borrowed the idea of action cut off into different compartments, each representing a separate episode, rather like a modern strip cartoon. The cross walls in the scene not only establish a series of spaces receding into physical distance: they also divide the successive earlier episodes of the story that led up to the dénouement in the foreground—the beheading of St. John in the distant dungeon and the bringing of his head on a charger past a gallery of musicians who have been playing for Salome's dance. The perspective in the scene is so calculated that our viewpoint seems to be right inside the banqueting hall, so that we experience the horrific drama at first hand. It all takes place within an actual depth of three inches.

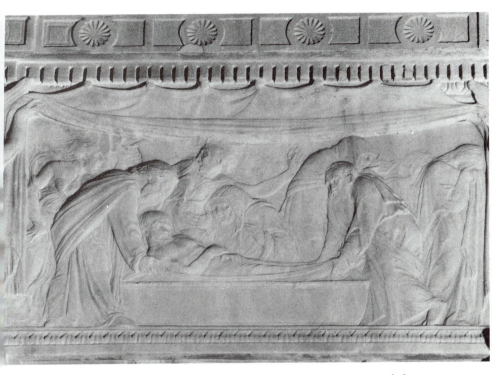

33. Donatello, *Tabernacle of the Blessed Sacrament,* 1432–1433. Detail showing the entombment of Christ. Sagrestia dei Beneficiati, Basilica of St. Peter, Rome

Donatello was so intrigued with the reconstruction of ancient Roman architecture that he let it dominate another rendering of the same story, which he carved in marble. It is really an exercise in correct perspective, the theory of which was being established by Brunelleschi at this time and codified by the theoretician Alberti in the 1430s [32]. However brilliant Donatello's evocation of the complex and impressive spaces of Herod's imaginary palace in this relief, it has to be admitted that the almost painful insistence on the lines and angles with which it is built up do tend to diminish the drama being enacted by the human figures within. Never again did Donatello allow his actors to become so subservient to their setting.

He found a better balance in a tabernacle for reserving the Holy Sacrament that he carved for St. Peter's, probably when he spent three years in Rome from about 1430 [33]. There, the architectural elements are real and structural, while the sculptures—in varying degrees of relief—are distributed on, or in front of, them: the groups of charming little angels

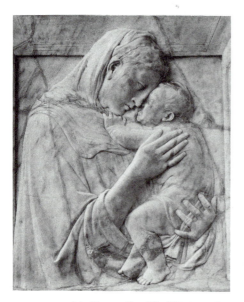

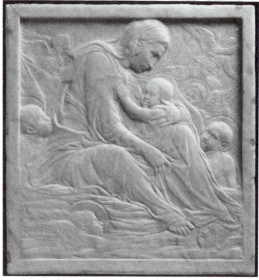

34. Donatello, *The Virgin and Child* ("*Pazzi Madonna*"), c. 1425–1435. Staatliche Museen Preussischer Kulturbesitz, Berlin-Dahlem

35. Donatello, *The Virgin of Humility* ("*Madonna of the Clouds*"), c. 1425–1428. Museum of Fine Arts, Boston

pressing in from each side to adore the sacrament are a subtle device to help the spectator focus his attention on the holy mysteries.

Above, Donatello again used low relief to depict Christ's entombment, which is revealed behind a curtain that is drawn aside by the flanking angelic attendants. Here the figures stand the full height of the available field and so dominate the scene, while their frenetic gestures and distraught expressions betray their anguish as their Savior is reverently laid to rest. Donatello was to return to this harrowing scene later in his life, when he carved an almost life-size version in Padua [62].

Between about 1425 and 1435, as far as one can judge, Donatello also used his novel technique of "drawing on marble" for images of the Virgin and Child [34]. The earliest is the so-called *Pazzi Madonna,* for the emphatically Grecian profile of the Virgin relates to those of the heads of a *Prophet* and a *Sibyl* that the sculptor contributed to the Porta della Mandorla of Florence cathedral in 1422, as well as to the classical heads at either end of the base of his tabernacle for the *St. Louis,* of similar date. The melancholy mood established by the profile head and the protective

way the Virgin hugs the baby to her were probably borrowed by Donatello from a particular type of Greek funeral stele, commemorating mothers who died in childbirth. It is characteristic that he adapted such a source to add a new dimension to his image of the Madonna—that of foreboding; for it was believed that she had a premonition of her child's eventual passion. The not quite accurate perspective of the deep embrasure through which we see the group and the crude foreshortening of the hand supporting the baby are also signs that this relief is among Donatello's earliest essays in the technique.

Similar in mood, because it reutilizes the same mournful classical source, is the *Madonna of the Clouds* [35]: however, the mother is here shown seated, not in an architectural frame but amid clouds, out of which pop various cherubs in full flight, rather as in the *Assumption of the Virgin* in Naples [26]. This panel is only one foot square, the figures are tiny and their scale relates to that of an oval marble *Madonna with Four Angels*, two

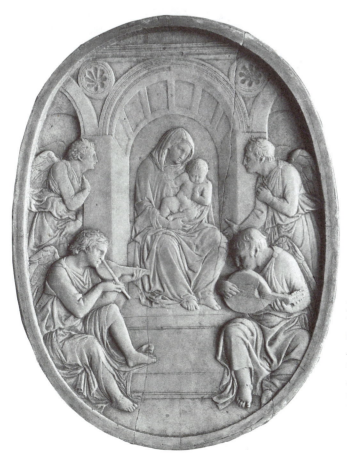

36. Donatello, *The Virgin and Child with Four Angels* (*"Hildburgh Madonna"*), c. 1425–1428. Victoria and Albert Museum, London

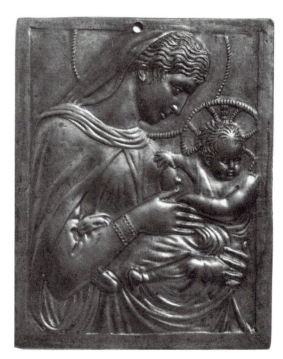

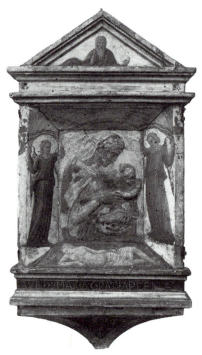

37. After Donatello, *The Virgin and Child,* c. 1427.
Victoria and Albert Museum, London

38. After Donatello, possibly painted by Paolo di Stefano (1397–1478), *The Virgin and Child,* c. 1427–1430.
Victoria and Albert Museum, London

playing stringed instruments (as well as to some bronze plaquettes mentioned below) [36]. The bold creation of space through a logically imagined and projected architectural setting and the sublety of carving on the drapery and hands of the figures relate this ambitious relief to the marble version of the *Feast of Herod* [32]. No other sculptor knew how to suggest space so convincingly and how to integrate his figures into it. The angel playing a viol in the left foreground is also a close cousin of the musician accompanying Salome's dance in the middleground of the Sienese gilt bronze relief, while the classical profiles of all four angels are also to be paralleled there, as is the arcaded setting. This confirms the date of the marble oval.

The composition is reminiscent of the central panel of the *Virgin and Child* from Masaccio's altarpiece for Pisa, painted in 1426, when the two artists were in touch there: so Donatello's oval version probably dates from his stay in Pisa, when he and Michelozzo were working on the production of the tombs for Montepulciano and Naples. The existence of plaster casts

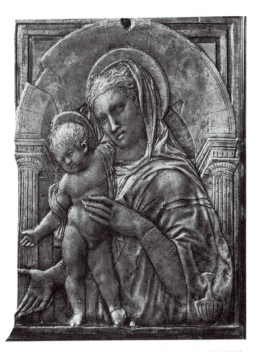

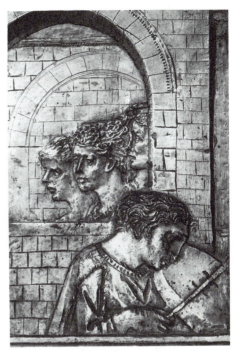

39. After Donatello, *The Virgin and Child before an Arch, with a Vase,* c. 1427–1430. The Wallace Collection, London

40. Donatello, *The Feast of Herod,* c. 1427. Detail of color plate I. Font, Baptistery, Siena

of this Madonna, which are realistically painted and made up into rectangles framed in gilt wood, corroborates the possible association of the original with the work of a painter.

Two bronze plaquettes of different sizes also stem directly from the *Feast of Herod* in Siena: evidently its creation demanded many different preparatory studies by Donatello and occasioned a burst of activity in relief sculpture, some of which found permanent expression in these small plaques. They lent themselves to commercial reproduction by casting in bronze or in stucco, which could then be painted [37; 38]. The bronze casts sometimes had an outer frame and handle on the back, enabling them to be used during the Mass, as a pax. In the smaller plaquette [37], the Grecian profile of Mary, with her wavy hair parted centrally and tied back behind the ears, is close to that of Salome, while the baby Jesus, with his head turned sharply back over his shoulder, recalls the two putti in the lower left-hand corner of Herod's feast.

The other, larger plaque, known also in gilt bronze and painted

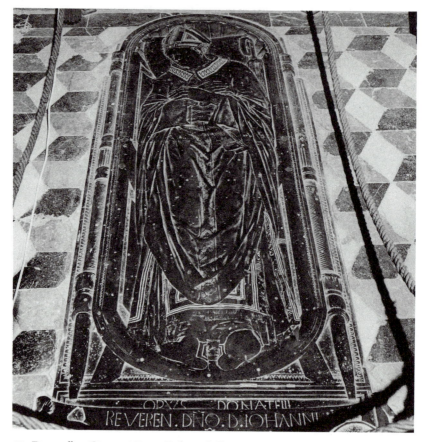

41. Donatello, *Giovanni Pecci, Bishop of Grosseto,* c. 1428.
Cathedral, Siena

stucco versions, shows the *Virgin and Child before an Arch, with a Vase* [39].
Much discussed though its authorship and status are, there is little doubt
that the composition is Donatello's and may date from as early as the
Sienese relief, for the ashlar masonry voussoirs of the arch accord with
those in Herod's palace, and the idea of a slipped—or missing—stone also
features there [40; Plate I]. The flattened-out, downward-looking, three-
quarters angle of the faces and the expressive, opened hands with incisively
articulated fingers are also to be found in the far central background and
right foreground in Siena.

From this period of activity in Siena in the mid-1420s dates one other
important bronze relief, the tomb slab of Bishop Pecci (d. 1426) [41]. This
was one of Donatello's most original creations, for instead of accepting the
convention of showing the effigy of the deceased in low relief lying on top

42. Donatello, *Faith,* 1428.
Font, Baptistery, Siena

of a slab, he chose to invent a sophisticated illusion of space *above* the floor of the cathedral and seen by us from an angle and in perspective. The bishop lies in a concave bier with a classical shell niche at his head, resting on short feet and with carrying handles projecting on each side from the near end. The motif of the shell niche recalls the real Brunelleschian shell niche that the sculptor had fashioned on Orsanmichele—for his *St. Louis.*

The decade from about 1422 to 1432 thus saw an amazingly intense and rapid development in Donatello's treatment of relief, completely breaking with tradition, making it the rival of painting and opening the way for the vivid, panoramic narratives of his later career.

Apart from the *Feast of Herod,* Donatello also contributed other items, about 1428, to della Quercia's font in Siena: two female figures of

Christian virtues, *Hope* and *Faith* [42], whose crinkly drapery remind one on a smaller scale of the *St. Louis,* and three baby angels, totally nude, balancing on tiptoe on upturned cockleshells within wreaths, arranged at the angles of the hexagonal marble pinnacle. They are directly descended from the baby shield-bearers in the knop of the crozier of *St. Louis of Toulouse* [44]. Instead of being confined in niches they move quite freely in space and are tantamount to bronze statuettes, such as shortly began to be collected enthusiastically by Renaissance connoisseurs, principally because of their reminiscences of an art form specially favored in ancient Greece and Rome.

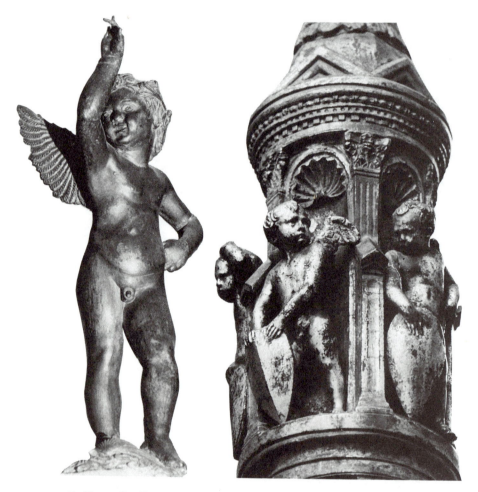

43. Donatello, *Putto,* c. 1429. Font, Baptistery, Siena

44. Donatello, *St. Louis of Toulouse.* Detail of Figure 14, the knop of the crozier

Donatello's Maturity and the Patronage of the Medici

———— § ————

DONATELLO seems to have been temperamentally unable to settle down. He had numerous changes of address and workshops and was notorious for running up bad debts against the quite modest rents he was due to pay. One begins to wonder if his much-vaunted, carefree attitude toward money was not a cover for dubious business practices: ten years after his death he still owed the Monastery of Santa Maria Novella thirty-four florins for rents due between 1429 and 1431! One of these workshops, which he shared with Michelozzo between 1431 and 1433, is on the corner of the cathedral piazza and Via dei Servi. Its original Gothic arches are marked with a commemorative plaque and a bust, and while those on the street corner now house a pizzeria, the next one still harbors a practicing metalsmith! From the backyard, where much of the foundry work was probably carried out, one gets a magnificent glimpse of Brunelleschi's dome.

Donatello evidently remained on good terms with the Medici after completing the tomb of John XXIII in the Baptistery. Giovanni di Bicci died in 1429 and Cosimo took over the leadership of the family and the bank, which boded well for the sculptor's fortunes. However, Florence was shortly to be at war and Donatello fled to Rome, where among other things he carved the tabernacle in St. Peter's Basilica [33]. Then in 1433, the Medici were exiled to Venice by a caucus of their enemies. However, Cosimo soon made a triumphant comeback and established himself yet more firmly at the helm of Florentine politics.

Between 1433 and his departure for Padua a decade later, Cosimo de' Medici allowed Donatello for a peppercorn rent of five florins per annum (between a quarter and a third of what he had been paying on the Piazza del Duomo) the use of an old tavern—the Albergo di Santa Caterina—and

45. The workshop of Donatello and Michelozzo. Piazza del Duomo, Florence

two adjacent maisonettes with a courtyard. The Medici had acquired these properties with a view to their ultimate demolition, in order to help clear a larger site for the great palace which they intended to build.

This subsidy to Donatello's activities probably carried with it a definite commitment on his part to specifically Medicean projects. So it was probably during this decade that Donatello carried out much of his work for them, including the sculptured decoration of the Old Sacristy of San Lorenzo, their nearby parish church. His work there is completely undocumented, but its cost was probably set off against the greatly reduced rent for his relatively spacious premises, so that no money actually changed hands or needed to be recorded in an account book.

Brunelleschi had completed the architecture by 1428, a year before Giovanni di Bicci died, and Giovanni was buried in a sarcophagus at its very center, under the marble table where vestments were laid out before service. The sacristy thus became a Medici mausoleum, despite the fact that they also owned the patronal rights to an adjacent chapel off the transept of the church.

The story goes that Brunelleschi fell out with his old friend Donatello over the dramatically modeled and brightly colored stucco reliefs which the

sculptor inserted within the gray sandstone architectural members and whitewashed walls of Brunelleschi's Renaissance design. It is understandable that an architect might prefer the stark effect of a blueprint to the decorative scheme that—presumably—his patron Cosimo preferred and called upon Donatello to execute.

The eight roundels with which Brunelleschi had decorated the pendentives of the vault and the tops of the side walls are over two yards in diameter. Donatello filled them with four scenes from the life of St. John the Evangelist, and portraits of all four Evangelists at their reading desks and with their symbols. These all had to be modeled in situ from a scaffolding, in superimposed layers of damp plaster; the architectural settings are cut in with rulers and sharp knives to excavate several successive layers of space toward the background; and the figures are made to adhere by building them up around nail heads hammered not quite flush with the surface [46]. They are modeled with great gusto, rather in the manner of twentieth-century sculptors such as Auguste Rodin or Sir Jacob Epstein. The spontaneity permits an impression of movement and hence of drama.

Now that Donatello had mastered the art of perspective, he was able effortlessly to project a great barrel-vaulted and arcaded hall—recalling an ancient Roman bathhouse—as the setting for the *Raising of Drusiana from the Dead* [47]. Cleverer still is the "skyscraper" effect of the *Ascension of St. John*. As if in the stalls of a theater, a spectator craning his head over the edge of the stage directs our eyes upward along the converging lines of the backdrop to the saint as he ascends to heaven. The horizontal division of space and the bold idea of having a figure in the foreground with its back to us are borrowed from a relief on the Arch of Constantine.

In the *Martyrdom of St. John* Donatello introduced diagonal lines in the handrail of the stairs and in the fire irons with which the executioners stoke the flames under the cauldron, which give thrust to the composition. The modern-seeming, almost photographic way in which he boldly cuts off figures around the periphery suggests that the drama continues beyond our field of vision. Here and there, one can see where the sculptor has scratched his preliminary design into the damp plaster, just as a fresco painter would sketch in sinopia his outlines on the damp plaster, before adding the final layer of *intonaco* on which he would paint in color. Again, the technical similarity with the processes of contemporary painters is revealing of Donatello's wide range of knowledge and talents. Seen in close-up, this is a virtuoso performance indeed.

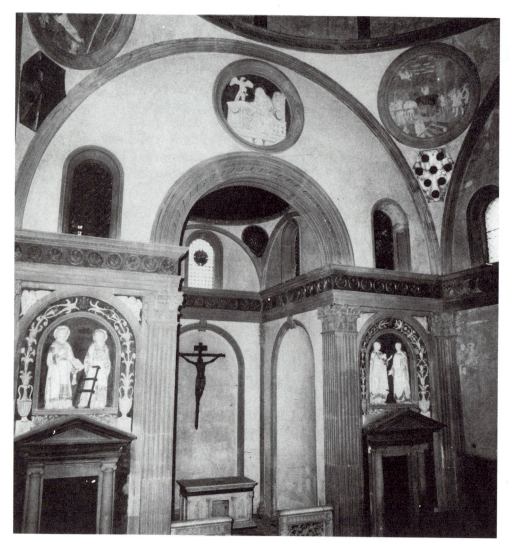

46. Filippo Brunelleschi and Donatello, Old Sacristy of San Lorenzo, Florence,
c. 1429, after conservation in 1986

On the side walls—as if through round windows—we are allowed to glimpse the four Evangelists in the privacy of their heavenly studies. Meditating upon the Gospel is St. Luke, with his winged ox; while perhaps the most moving and imaginative portrait of them all is the one of St. John, a pensive and melancholy sage, attended by his eagle [48].

Donatello's other major contributions were the two round-headed reliefs over the doors to the inner sacristies, which show St. Stephen and St. Lawrence (patron of the church) and the Medici patron saints Cosmas and Damian, the doctors, after one of whom Cosimo himself was named. These panels, within their broad, outer frames modeled with stylized plants in classical ewers, are unhappily balanced on the apexes of the pediments above the doors below, and this may have been one of the causes of Brunelleschi's complaints.

The martyrs' heads are powerfully modeled and their features exaggerated in an attempt to dramatize them. Like the roundels above, the figures were directly modeled on the spot and were then painted white and enlivened with gilded details on their garments, while the backgrounds were painted blue—a color scheme that corresponds with the glazed terracotta sculptures of Luca della Robbia of a few years later. A thorough program of cleaning by the Superintendency of Monuments in Florence has revealed the startling original effect after layers of dirt, discoloration and overpaint have been painstakingly removed. The brightness of the colors that have come to light gives us an inkling of why Brunelleschi may have taken such violent exception to them.

Cosimo's biographer, Vespasiano da Bisticci, wrote: "Since in his time the art of sculpture suffered some lack of employment, Cosimo, to prevent this happening to Donatello, commissioned him to make certain doors which are in the Sacristy, and gave orders to his bank to allow him a certain sum of money every week, enough for him and his four apprentices, and in this way he kept them." This arrangement was made by the worldly wise Cosimo not to ease the cash flow of the huge Medici bank, which would have been unnecessary, but to help the naive artist manage large sums of money.

While the pulpits certainly date from the end of Donatello's career, the doors are not radically different in mood or style from the modeled stucco decorations of the sacristy. They may in fact have been produced at the same period, between 1433 and 1443. The scheme of the doors seems to reflect a knowledge of Roman and early Christian ivory consular diptychs, although they hinge outward from the sides rather than inward

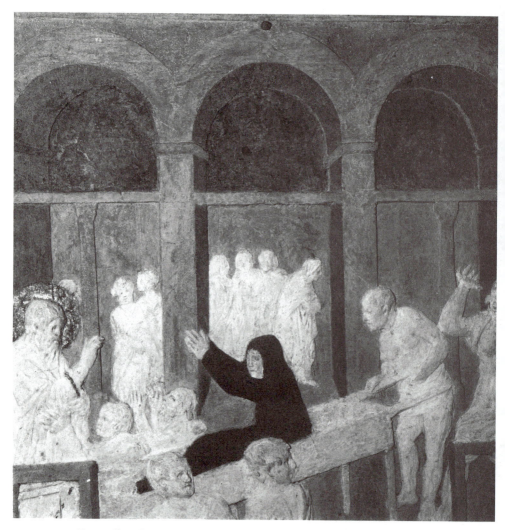

47. Donatello, *The Raising of Drusiana from the Dead,* c. 1435–1440. Detail.
Old Sacristy, San Lorenzo, Florence

48. Donatello, *St. John the Evangelist,* c. 1435–1440.
Old Sacristy, San Lorenzo, Florence

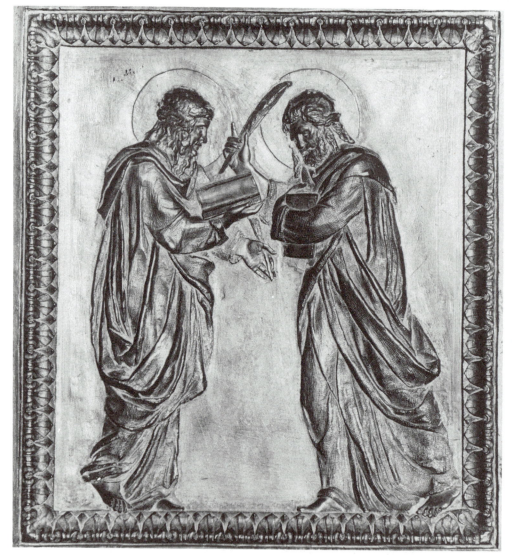

49. Donatello, *Martyrs' Doors,* c. 1435–1440. Detail of one panel.
Old Sacristy, San Lorenzo, Florence

at the center. However, Donatello was not content to show his pairs of martyrs or saints in harmonious symmetry—no, they had to be dramatized almost to the point of caricature, as they ponder or dispute points of theology [49].

The architect-theoretician of the arts, Leon Battista Alberti, seems to have known these designs in time to have criticized them in his book *Della Pittura (About Painting)* of 1436: "it befits a runner to flail his arms as much as his legs, but a discoursing philosopher should show restraint rather than behave like a fencer."

The way some of the martyrs are shown brandishing their quill pens or symbolic palms at one another could well have given rise to Alberti's simile of fencers. Equally suggestive that this was the subject of his critique are further remarks that "those who for the sake of suggesting movements and vivacity twist their figures into incongruous poses, showing back and front at the same time," will be left with "fencers and acrobats without any artistic dignity." Certain panels on both sets of doors are guilty of this charge: today, however, we would probably give Donatello the benefit for enlivening an otherwise rather uninspiring theme.

During the mid-1430s Donatello was also involved in bringing to completion an external pulpit for Prato cathedral that had been commissioned some years before, in 1428. This was an outdoor gallery jutting out from the southwestern corner of the cathedral well above ground level [50]. It was designed for the display of the most venerated relic in Tuscany, a sash that was held to have been the Virgin Mary's: she had lowered it to earth to reassure the doubting Thomas that her Assumption into heaven was actually occurring. The pulpit is three-quarters of a circle in ground plan and is supported by abutting pilasters on the corner, with a great bronze capital modeled by Michelozzo. Donatello with his fecund imagination and wide knowledge of Roman sarcophagi with putti must have invented the lively models for the running and dancing putti. Their action is implicitly continuous, though it is divided into separate panels and is meant to continue even inside the walls of the church, round the quarter circle that one cannot see but can imagine. They must have been meant to be making merry at the annual display of the relic and perhaps symbolize the souls of the innocent in Paradise.

Surprisingly, the partners seem to have lost interest in this commission and even went off to Rome for three whole years in the meantime. External reasons, such as the hostilities that had broken out in Tuscany, may have discouraged them. Eventually, the Prato authorities had to ask

50. Donatello, Michelozzo and assistants, external pulpit, 1428–1438.
Detail of one panel of putti. Cathedral, Prato

Cosimo de' Medici to intervene on their behalf with Donatello, for he was
being so dilatory in meeting any contractual deadlines: Cosimo was the
only person who had any influence over the willful sculptor. Even so,
Donatello delegated much of the carving to assistants and himself concen-
trated on a more prestigious and challenging commission, a singing gallery
for the crossing of the cathedral in Florence [51].

By the early 1430s, Brunelleschi had nearly completed the great dome
of Florence cathedral, and as part of the internal fittings two choir galleries
were commissioned to be set over the doors of the twin sacristies. Probably
because Donatello and Michelozzo were away in Rome, the first gallery
was ordered in 1431 from a hitherto obscure sculptor from the cathedral
workshop, Luca della Robbia. It is a masterly combination of architecture
and relief sculpture in the new Renaissance style. The theme of its ten
panels is a choir singing and enacting the verses from the triumphant
Psalm 150, which is inscribed in classical lettering above and below the
panels: Luca's design probably reflects prior knowledge of the pulpit at
Prato, but is more logical in conception and staid in execution and mood.
Luca's vision is as delicately poetic as Ghiberti's in the panels that he was
currently preparing for his *Gates of Paradise*.

Well before the pulpit at Prato was finished and not long after Donatello had been induced to return from Rome, in July 1433, the Board of Works of Florence cathedral commissioned him to produce a choir gallery as a pair to Luca's: there was a clear implication that Donatello was to match Luca's panels and it was firmly stated that if his were up to the standard set by Luca he should receive forty florins each, but anything up to fifty florins if they were judged superior. Donatello threw himself into this new task single-mindedly and with an alacrity that would have surprised and annoyed his frustrated patrons at Prato. A window in the side chapel where he was to carve the gallery was closed with a sheet of linen, probably to help exclude the cold, on November 23, 1433, and a month later payment was made to a quarryman who had supplied a slab of marble nine feet long for Donatello to carve. Two other slabs were delivered to Luca at the same moment, as he proceeded with his gallery.

The length of this slab of marble indicates that Donatello had already decided, with a bold stroke of the imagination, to develop the idea of his Prato design into a literally continuous frieze of cavorting putti [52]. On the choir gallery they run uninterruptedly along behind the freestanding

51. Donatello. *Singing Gallery (Cantoria)*, 1433–1439.
Museo dell' Opera del Duomo, Florence

colonnettes of the architecture. They are in fact carved out of two long slabs totaling just over six yards in length. Donatello bore in mind that the situation of the Florentine gallery indoors and in the ill-lit crossing was quite different from that in Prato, in the full light of day. He therefore decided to cut the figures in much deeper relief, to let the colonnettes stand free in front of them and to cover the background with gold mosaics to catch any available light from the candles round the choir enclosure under the crossing. Indeed the highly ornamented architecture, many motifs of which are derived from Etruscan prototypes, is encrusted with multicolored mosaics, in a way which, to our eyes, is thoroughly unclassical. Mosaics had been much used in Gothic sculpture for the same reasons, by sculptors such as the Cosmati and Arnolfo di Cambio.

Gone are the calm logic and clarity of Luca's scheme; in no way would Donatello content himself with matching Luca panel for panel, even if he *were* paid slightly more! In any case he was clearly bored with the type of solution which his assistants were currently bringing to completion for Prato. Utilizing the fitful, flickering light that would be available, Donatello seems to have set himself a daunting task, to convey an impression of actual movement in his dance of putti.

They do not move in one direction only, for while the figures in the front are clearly shown running from right to left, others behind are moving in the opposite direction. There is a mêlée of chubby legs and arms flying all over the place. Their visibility is obscured by the colonnettes, but each of the two long panels depicts a self-contained dance—two kinds of "ring-a-ring of roses"; on the left panel the baby angels hold hands—or each other's forearms—while on the right panel they are linked together by tightly bound, classical wreaths of laurel, held in either hand. Their feet pound on a bed of leaves: bullrushes, acorns and convolvulus can be made out among the foliage. An attention to botanical detail was normal in contemporary International Gothic painting—for instance, in Gentile da Fabriano's *Adoration of the Magi* in the Uffizi Gallery. Soon it was to become a favorite ingredient of Luca della Robbia's sculpture in glazed terracotta, a specialty that he pioneered shortly after finishing his choir gallery. Donatello's main work on the gallery was finished by 1440, and he crowned it with a pair of smiling bronze cherubim holding candlesticks to illuminate the choral books (Musée Jacquemart-André, Paris).

Similar in its architectural sources to the choir gallery—and probably therefore of much the same date—is an undocumented work that Donatello carved for a chapel in Santa Croce belonging to the Cavalcanti family. This was his famous life-size tableau in gray Tuscan sandstone—*pietra*

52. Donatello, *Singing Gallery*. Detail, the frieze of dancing putti

serena—of the Annunciation, which is built into the outer wall of the south aisle [53]: unfortunately its immediate surroundings were destroyed when Vasari "rationalized" the church in the sixteenth century. We do know, however, that it was adjacent to a life-size fresco by Domenico Veneziano of St. John the Baptist, patron saint of Florence, and St. Francis, founder of the order that managed Santa Croce [54]. This was on a sidewall projecting at right angles from the main wall of the church, and on the viewer's right when looking toward the *Annunciation*. Indeed it is probable that the *painted* architectural molding on which the saints in the fresco stand was on a level with the *real* architecture of Donatello's tabernacle, for the feet of the saints are shown as though we were meant to be looking up from below—*di sotto in su,* as the Italians say. The left side of the pretense niche under which the saints stand is shown, while the right side is hidden. This predicates a point of view diagonally from the right of the fresco. In fact, the two works of art probably formed an entity: St. John's lowered right hand and tilted head—as well as his right toes projecting over the molding—all would have related him to the *Annunciation,* and so does the direction in which St. Francis appears to be worshiping. The pair

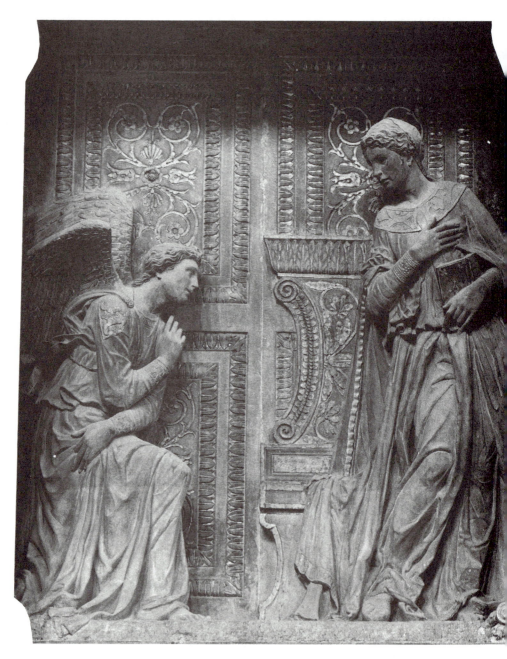

53. Donatello, *The Annunciation,* c. 1428–1433. Santa Croce, Florence

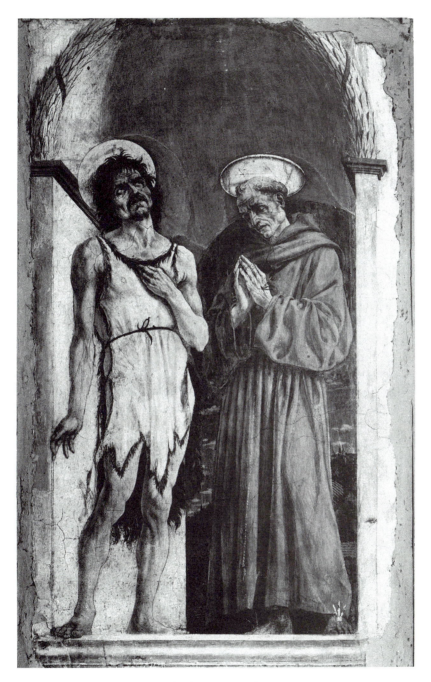

54. Domenico Veneziano, *St. John the Baptist and St. Francis,* 1450–1460.
Museo dell' Opera di Santa Croce, Florence

of saints are like the right wing of a triptych that has been opened at an angle to the center of an altarpiece. Donatello carved the Angel Gabriel and Mary almost three-quarters in relief within a shallow stagelike space, so they have the visual impact and psychological immediacy of a tableau vivant, such as the congregation would have been used to in the miracle plays that were customarily enacted in (or outside) the church.

The Virgin rises, startled and shy, but not unduly alarmed and withdraws almost offstage to the right, gazing down at the kneeling angel, who delivers his message with awe and sympathy [Plate III]. Donatello interprets the Bible story with a sympathetic insight into the emotions that might have been involved: at the same time he enhances the spiritual grandeur and serenity of the figures by giving them idealized, classical heads. Donatello may have used ancient Roman facial types not just for their beauty, but as an absolutely historical indication of the period when the event depicted actually took place—at the height of the Roman Empire.

The tenderness and delicacy of mood in the *Annunciation* provide a contrast to Donatello's obvious delight in the more harrowing emotions that we have seen in his depiction of prophets, Evangelists, saints and martyrs, for instance on the Campanile statues and the reliefs in the Medici Sacristy at San Lorenzo. During the last fifty or sixty years—the years of "Modern Art" and especially German Expressionism, the years when the history of art has been codified—the dramatic side of Donatello's nature has been greatly admired, to the exclusion of the sweeter side. In fact, Donatello was a gifted exponent of the sweeter emotions when they were appropriate to his subject, as we have already seen in his renderings of the theme that provided "bread and butter" for sculptors throughout the Middle Ages and continued to do so in the Renaissance: the Virgin and Child.

It has often been implied that the two sides of Donatello's artistic personality, the sweet and charming, as opposed to the dark and dramatic, come to the fore at different periods. There has been a tendency to regard the sweeter and more idealized, classical statues as earlier and the more haggard and intense ones later. This is a fallacy, as is demonstrated by the recent discovery of a signature and date on a painted and gilded wood *St. John the Baptist* in the church of Santa Maria Gloriosa dei Frari in Venice [55]. It had often been thought to be a work of Donatello's later career, because it is rather like the other painted wood statue of his, the *Mary Magdalene,* which is generally accepted as dating from the end of his life [79]. However, the statue is dated 1438 and so must have been carved in Florence before Donatello ever went to northern Italy. Its similarity in appearance to the *Magdalene* is simply due to the fact that both saints are

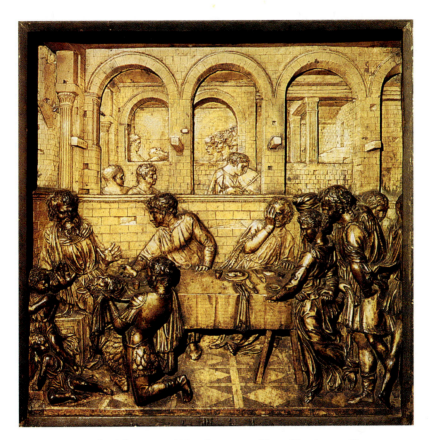

Plate I. Donatello, *The Feast of Herod,* c. 1427. Font, Baptistery, Siena

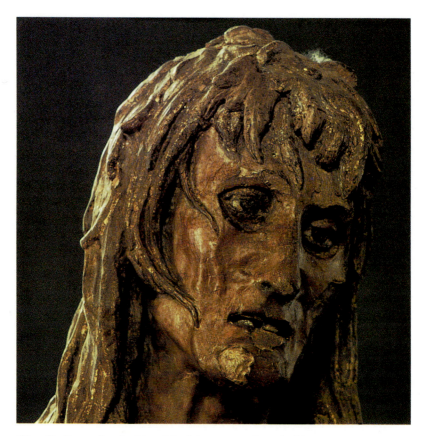

Plate II. Donatello, *St. Mary Magdalene,* 1454. Detail of Figure 79.
Museo dell' Opera del Duomo, Florence

Plate III. Donatello, *The Annunciation*. Detail of Figure 53.
Santa Croce, Florence

Plate IV. Donatello, *The Virgin and Child (flanked by St. Anthony of Padua and St. Francis),* 1447–1448. High altar, Basilica of St. Anthony, Padua

55. Donatello,
St. John the Baptist,
1438. Santa Maria
Gloriosa dei Frari,
Venice

always shown as starving hermits of the caves and deserts. It was therefore appropriate to depict them in an alarmingly wild way.

Wood may have been chosen for the *St. John* because of its lightness and resilience, which would facilitate its transport to Venice. The statue was destined for a chapel of the Florentine merchant colony in the Frari, and it may have been paid for by Cosimo de' Medici and his brother, who had spent their brief exile in 1433 contentedly in Venice, among their fellow countrymen. The Florentine colony wrote to them shortly after their triumphant return to their native city to remind them politely of their moral obligations to the community. St. John being the patron saint of Florence and a name saint of Cosimo's father, what would be more natural than that they should meet their obligation by giving a luxuriously painted and gilded statue of him by the greatest sculptor of the day, who was living on their own premises, and who was virtually in their personal employ? This terrifying and dramatic image was probably carved within a few years of the Cavalcanti *Annunciation,* and a comparison shows how Donatello could transform his style and treatment to suit his subject, in conformity with the classical notion of "decorum."

Donatello forsook Florence in 1443 to attend to major commissions in Padua. Quite why he came to leave has not hitherto been explained, but recent archival work has shown that precisely in 1443 Cosimo de' Medici had completed the lengthy process of acquiring all the properties near the old Medici town houses so that a whole city block could be demolished to clear a site for the massive new palace that he wished to build. One victim of this was the old Albergo di Santa Caterina, which for the whole past decade he had been letting as a workplace to Donatello. So the sculptor, by now fifty-seven years old, simply had to move, and because of his temperament, it may have been in a fit of pique that he took off for Padua. Before leaving Florence on March 21, 1443, the sculptor bought for twenty-three florins a house with a "little bit of garden" at Figline near Prato. This clearly implies that he intended to return to Tuscany sooner or later. He may have saved up a capital sum and bought it as an investment, but this does not accord with his normal spendthrift habits. More probably, it was given to him by Cosimo de' Medici to compensate for the loss of his premises and to encourage him to return, once the new palace was built. In fact he returned to Florence just when the palace was nearing completion and ready for interior decoration, a decade later, in 1454, and this can hardly be a coincidence.

The Paduan Decade
1443–1453

———— § ————

THE background to Donatello's journey was that on January 16, 1443, there had died in Padua a famous *condottiere,* or mercenary soldier, who was captain general of the army of Venice. His name was Erasmo da Narni, but he is better known by his nickname Gattamelata—"the spotted cat." Donatello was to commemorate him with an equestrian monument in bronze, which stands on a marble pedestal outside the Basilica of St. Anthony in Padua, in what used to be the cemetery [56]. A Florentine banker, a member of the Strozzi family, managed the payments to him from Gattamelata's widow and it may have been he who suggested Donatello's name to the executors. An opportunity to rival the famous equestrian statues of ancient Rome, such as the *Marcus Aurelius,* would have been a great inducement to an ambitious sculptor who was at the height of his career. The project would also be very expensive, and the artist could expect to be rewarded accordingly. Much of the work took place in 1447 and was carried out by the same team as were by then producing bronzes to Donatello's designs for the Basilica.

The horse is shown as though pausing momentarily with one forehoof balanced on a cannonball. This provided a convenient support to stabilize the group—for the great problem of statues of horses is the relative thinness of their legs, which have to support the weight of their own body as well as that of the rider. Iron armatures are normally embedded in the casting and cemented firmly into the base to achieve rigidity, and to this end four legs are better than three! A hoof raised off the ground, as the ancients had managed, was useless for support, and indeed increased the mechanical problems of balancing the whole.

The staunch war-horse is based on Greco-Roman prototypes such as the horses on St. Mark's, nearby in Venice, while the rider wears a fanciful

version of Roman uniform combined with elements of contemporary armor. His commander's baton is Roman in inspiration too, yet the long sword is not. Much of the detailing on the saddle and armor is classical, though it would not have been found in military contexts—in particular, the masks with radiating petals are copies of Etruscan end tiles on temple roofs!

The head has the hard-bitten look of a man of action—the slight frown, tightly clenched teeth and lips, the sallow cheeks and temples, the hair cropped close to the skull, and unkempt. Yet Donatello must have used a good deal of imagination—and perhaps threw in for good measure borrowings from an ancient Roman portrait of an imperator—for Gattamelata had died after a number of strokes at the age of seventy. Donatello showed the commander not as he was, but as he might have looked on the field of battle in his heyday.

While Donatello was making the statue of the captain in bronze, so we are told, he felt he was being pestered too much, so he took a hammer and smashed in the head of the statue. The government of Venice ordered him to come before them and threatened to smash in his head, just as he had the statue's. Donatello cheekily replied: "I will be quite happy, if you have got the heart to remake my head afterward, as I will remake your statue's." This unlikely episode may be read as an allegory of the sculptor's notoriously obstreperous attitude toward employers and their demands, even when these were perfectly reasonable.

In fact he *did* have difficulties with his patrons over pricing his work on the equestrian statue, but they were the executors of Gattamelata and not the government of Venice, as depicted in the story. The verdict of the assessors upheld Donatello's claims not only for time and money spent, but for the "great mastery and ingenuity that there had been in the making and casting of the said horse and rider." This is evidence of an increasing appreciation in the fifteenth century of the technical skill and imagination that went into producing a major work of art, above and beyond the mere costs of materials and craftsman's labor, the basis on which prices had traditionally been assessed.

Because of disputes with the Venetian Senate over the location and nature of the projected equestrian monument, the first work Donatello actually executed in Padua was *inside* the Franciscan Basilica of St. Anthony—a major shrine for pilgrims. This was a life-size crucifix to go half way up the church [57]. Throughout 1444 materials to make it were purchased: iron for the armature to support the model; bronze for casting

56. Donatello, *Erasmo da Narni ("Gattamelata")*, 1443–1447.
Piazza del Santo, Padua

it; wax for the original model; and even wine, to lubricate the sculptor's throat!

The challenge of producing a life-size nude figure was compounded by the sanctity of its subject and of its location in the basilica, as well as by the tortured way in which the Savior was to be shown dying. The result must have amazed Donatello's spectators. He managed to strike a balance between classical anatomical beauty and effects of suffering on which Gothic art—still the predominant fashion in northern Italy—tended to dwell. He also wished to ennoble the figure as the Savior of mankind. He seems to have held in check his instinct to dramatize the image with expressionist devices, such as he had used in the wooden statue of the Baptist for the Frari church. Only the straggling hair indicates the agony of the Crucifixion.

On April 13, 1446, a rich wool merchant left an enormous bequest of 1,500 lire for a new altarpiece for St. Anthony's and further sums were subscribed soon after. He may have had in mind a large painting, but the authorities commissioned Donatello and a team of assistants—some from

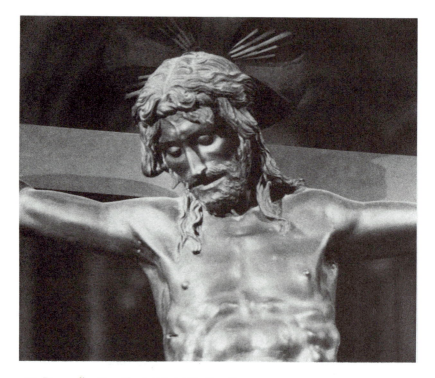

57. Donatello, *Crucifix,* 1444–1447. Detail.
Basilica of St. Anthony, Padua

Florence and some local—to produce a sculptural retable instead. They
had probably been impressed by the great bronze crucifix that they had
just seen him produce so quickly.

The high altar presented a sort of *tableau vivant* with six freestanding,
life-size bronze saints grouped around the central Virgin and Child, under
a Renaissance marble canopy supported on columns [Plate IV]. Around
the altar below are a series of bronze reliefs—four major panoramic
narratives showing miracles performed by St. Anthony, separated by sym-
bols of the four Evangelists, twelve upright panels with *Musician Angels,*
and a *Pietà* [59; 60; 61].

What we see today is an inaccurate reconstruction designed in 1895.
Scholarly opinion is divided over the disposition of the reliefs, the relation-
ship of the saints one to another and the precise nature of the architectural
tabernacle containing them. Donatello proposed a sculptural equivalent to
the normal type of painted altarpiece showing the Virgin and Child flanked
by saints—a *Sacra Conversazione*—or "Holy Conversation" as the Italians

call it. A good idea of its intended appearance is given by Mantegna's slightly later painted altarpiece in the church of San Zeno in Verona, which probably reflects Donatello's scheme [58]. A tabernacle with four columns across separates the Virgin and Child from the flanking saints, with a curving cornice above. The narrative reliefs were to form the predella—that is, the smaller scenes confronting the priests when celebrating mass on the altar—and the *Musician Angels* were to be interspersed between them and the four panels of symbols of the Evangelists and the *Pietà*. The altar was a freestanding structure in the middle of the choir, so this zone would run around all four sides of a rectangle, while the saints above could also be seen from all sides. On the back of the altar was the *Entombment of Christ,* a large relief panel executed in colored marbles and enhanced with mosaics to assist visibility, as on the choir gallery for Florence cathedral [62]. Into an impossibly tight space, Donatello packs eight followers of Jesus: the men with looks of stoic resignation reverently lay the corpse to rest, while behind, the three Maries tear their hair, gesticulate wildly and wail in anguish—like maenads in a Bacchic rout on a Roman sarcophagus. The feeling of claustrophobia heightens the tension. The treatment recalls Donatello's earlier essay on the *Tabernacle of the Blessed Sacrament* of St. Peter's [33].

Once the commission had been awarded, presumably on the basis of detailed models, work went ahead with great rapidity. Donatello emerged as one of the great entrepreneurs of the history of art, welding the efforts of a disparate team of assistants with varied skills and backgrounds into a homogeneous style that is to all intents and purposes his own. By June 13, 1448, all seven statues had been cast, together with all the reliefs except the *Pietà,* and a trial wooden altar was prepared by carpenters to display them for St. Anthony's day.

The axis of the group is the *Virgin and Child,* a role emphasized by the unusual way in which the mother holds her baby in front of her. This is a device from Byzantine art, where the Child was meant to be shown symbolically in the Virgin's womb, visible as though by X-rays. It had also been re-used in more recent medieval sculpture.

Probably flanking the Virgin were *St. Francis* and *St. Anthony.* Donatello seems to have tried to evoke their characters by relying on actual portraits of them: the head of *St. Francis* is palpably close to Cimabue's fresco in Assisi [63], while an early fresco of St. Anthony—on one of the piers of the chancel of the basilica—evidently provided the model for *his* statue.

The modeling of their faces is bold and impressionistic, with little

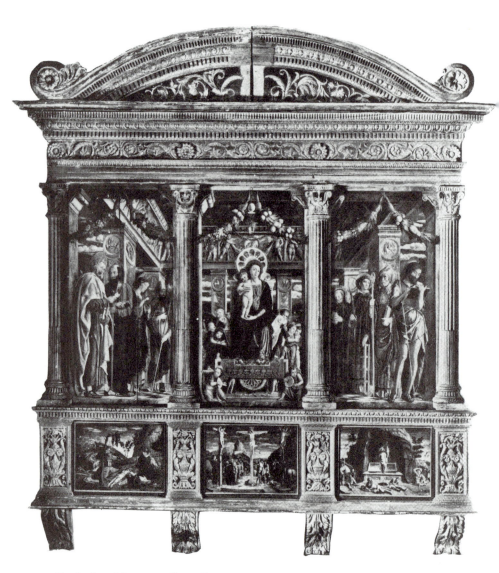

58. Andrea Mantegna, *Sacra Conversazione,* 1456–1459.
San Zeno, Verona

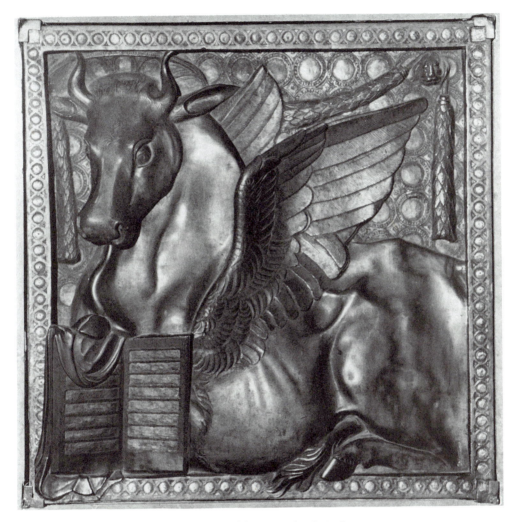

59. Donatello and assistants, *Symbol of the Evangelist St. Luke,* 1447–1448.
Basilica of St. Anthony, Padua

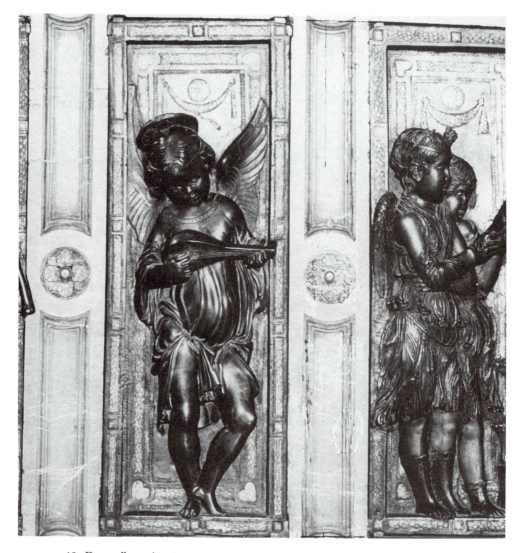

60. Donatello and assistants, *Musician Angels,* 1447–1448.
Basilica of St. Anthony, Padua

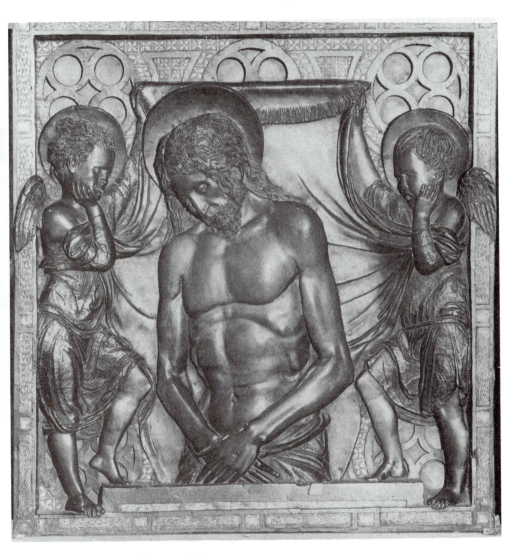

61. Donatello, *Pietà*, 1447–1448.
Basilica of St. Anthony, Padua

detail, though the bone structure is perfectly apprehended. This gives an unprecedented grandeur and pathos to their features. The emotional pitch is, for Donatello, restrained, in view of the normal mood in such an altarpiece, where the saints attend on the Queen of Heaven and their earthly travails are sublimated in the life hereafter.

The figures are not highly finished—unlike the predella panels— partly because of the deadlines they were forced to meet for various feast days; partly because they were never visible from close-up or in a good light; and partly, perhaps, because Donatello realized that this allowed a more expressive effect. It left scope for the spectator's imagination to operate—like the *sfumato* effect used a generation later by Leonardo da Vinci. The play of flickering candlelight across the deeply shadowed faces of Donatello's groups of saints, majestically disposed behind the altar, must have conveyed an impression of physical and spiritual presence that

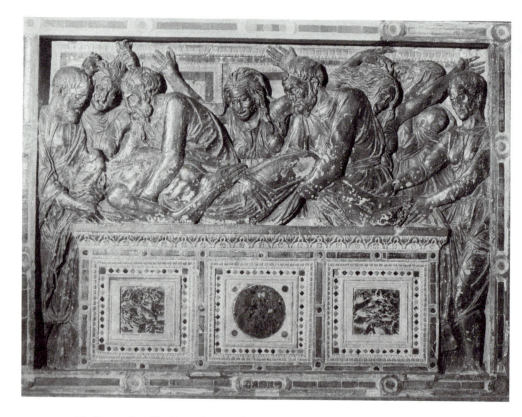

62. Donatello, *The Entombment of Christ,* 1449.
Basilica of St. Anthony, Padua

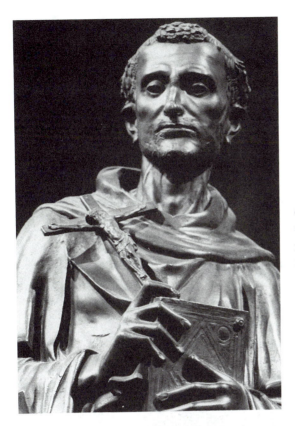

63. (*Left*) Donatello and assistants, *St. Francis,* 1447–1448. Detail. Basilica of St. Anthony, Padua

64. (*Below*) Donatello and assistants, *St. Giustina,* 1447–1448. Detail. Basilica of St. Anthony, Padua

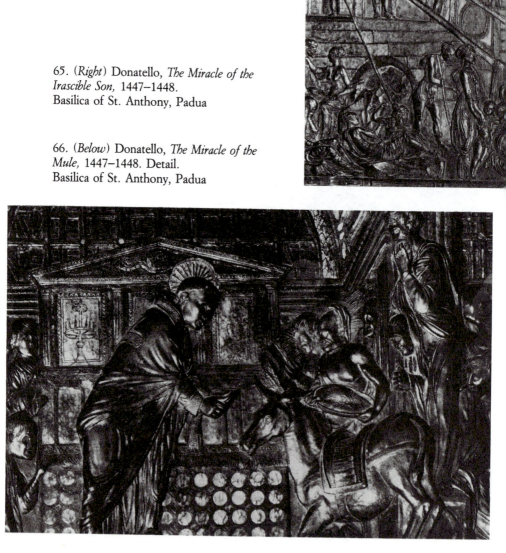

65. (*Right*) Donatello, *The Miracle of the
Irascible Son,* 1447–1448.
Basilica of St. Anthony, Padua

66. (*Below*) Donatello, *The Miracle of the
Mule,* 1447–1448. Detail.
Basilica of St. Anthony, Padua

would have captured the imagination of every pilgrim to the shrine of St. Anthony.

By contrast, the four stories from the life of St. Anthony are brilliantly finished; these were of course easily visible, being right before the eyes of the priests and acolytes and of any visitor who might be privileged to approach the high altar [65; 66].

The intricacies of the architectural settings are picked out in gilding or silvering, which suggest varying intensities of internal light in the scenes. Donatello fully exploits the various spaces plotted by his complicated architecture, articulating the crowded scenes in two cases by prominent pilasters with figures standing directly in front of them, above the general level of the crowd.

An effect of excitement is conveyed by the varied poses of the bystanders, and the drama is intensified by vigorous movements on or off stage to either side, with some figures only partly visible. Donatello worked with precisely the same intention as a theater or film producer does today: to create the maximum psychological and emotional intensity with the human resources available to him, in order to captivate the audience and convince them of whatever message he wishes to convey.

Miracles, such as the mule that knelt in homage before the Host at a mass celebrated by St. Anthony, today would tend to be dismissed as amusing medieval folktales, but for Donatello they were obviously deeply felt and meaningful religious experiences. He was intensely involved in the dramas, which he visualized as though they were part of the rough and tumble of life in fifteenth-century Italy. In the background, he gives rein to his imagination in passages of architectural fantasy reminiscent of such earlier reliefs as the *Feast of Herod*.

The Miracle of the Irascible Son may have had a personal resonance for Donatello. The saint is replacing a severed foot, which a son had rashly cut off as a penance for insulting his mother. This was exactly the sort of momentary overreaction to which the quick-tempered sculptor was himself prone. He may have wished that a St. Anthony could have as easily put to rights the bronze head he had smashed to pieces when a patron failed to pay the agreed price!

The event occurs in an amazing outdoor stadium with banks of seats at the sides and a few spectators leaning against the railings—strategically placed by Donatello so that their diminishing size might enhance the effect of recession into depths, set up by the architectural lines.

While there is a remarkable amount of detailed observation and sensitive characterization in these scenes, the strength of the compositions and clarity of the focal points prevent a feeling of overcrowding or pettiness. By comparison with the experimental phase represented by the reliefs of the life of St. John the Evangelist in the Old Sacristy of San Lorenzo of perhaps a decade earlier, there is a feeling of ancient Roman grandeur and harmony that shows Donatello at the height of his powers.

The intensity of feeling and immediacy of the dramas depicted make a strange contrast with the set of reliefs from the Old Testament which his Florentine rival Ghiberti was about to unveil on his *Gates of Paradise* in Florence. Donatello probably knew them, for they had been in the process of composition and casting ever since the late 1420s. Ghiberti failed really to integrate his figures into the architecture he depicted and failed to express their emotions with the same stark intensity. Looking at the *Gates of Paradise,* we can survey the stories calmly without being drawn into the dramas at all, for Ghiberti fails to engage our emotions by empathizing with his actors.

The end of Donatello's stay in Padua was marred by disputes over payment for the splendid bronzes he had produced: that over Gattamelata lasted until late 1453 and that over the bronzes for Sant' Antonio was still

outstanding in 1456—two years after he had left the city to return to Tuscany. Such disputes are not always one-sided, but our sympathies must lie with the artist who in one fell swoop had introduced the Florentine Renaissance into northern Italy and thus totally altered the course of the history of art in Padua, Venice and further afield. This process was to be continued by his own followers Bellano and Riccio in sculpture and by Andrea Mantegna and Giovanni Bellini in painting.

At this late stage in his career Donatello was being solicited from all sides. In 1450 he produced seven portable sculptures or reliefs, including three *Madonnas,* for Ludovico Gonzaga in Mantua and then played with the idea of going to work in Modena. There he was to have produced a statue of Borso d'Este in gilt bronze: he actually did a certain amount of work over the next year or two, before abandoning it. Alfonso of Aragon, king of Naples, also tried to hire him from the doge of Venice by offering to pay whatever they thought they owed him on the Gattamelata monument. This overture seems to have failed too, possibly because Donatello preferred to return to his native city. The Medici palace was just being completed and Cosimo may have made overtures to him that are not recorded. The crusty old sculptor later claimed that he had been glad to return to Tuscany "in order not to die among those frogs of Padua."

Siena and the Last Works
for Cosimo de' Medici

———— § ————

B Y NOVEMBER 1454 Donatello had rented a house and workshop
in Florence, not a stone's throw from his former premises. For the
next three years, until he moved to Siena in 1457, we have no
precise documents as to what he was doing. However, we do know that
in August 1456 Donatello was rather ill, for it was then that he had to give
a bronze roundel of the Virgin and Child to his doctor, Giovanni Chellini,
in lieu of a fee [67; 68]. In his ledger Dr. Chellini noted: "I record that
on August 27, 1465, while I was treating Donatello, the singular and
principal master in making figures of bronze and wood and terracotta, he
of his kindness and in consideration of the medical treatment which I had
given and was giving him for his illness, gave me a roundel the size of a
trencher in which was sculpted the Virgin Mary with the Child at her neck
and two angels on each side, all of bronze, and on the outer side hollowed
out so that molten glass could be cast on to it and it would make the same
figures as those on the other side." The doctor does *not* say that Donatello
had made the roundel specially for him, indeed it is unlikely that he was
in a position to, if he was still in ill health. Also, casting glass replicas was
an idea that would appeal to a sculptor, as it represented an extra and
novel source of income, and not to a doctor. Actually, casting replicas of
Madonnas was perfectly common as a commercial activity in Florentine
sculptors' workshops, though they were normally cast in clay, plaster or,
if small, in bronze, but never in glass. The sheer originality of the idea is
typical of Donatello, and the use of glass may have been deliberately avant
garde: it suggests that the roundel may have been made when he was in
Padua, not a dozen miles from that great center of glass production, the
Venetian island of Murano.

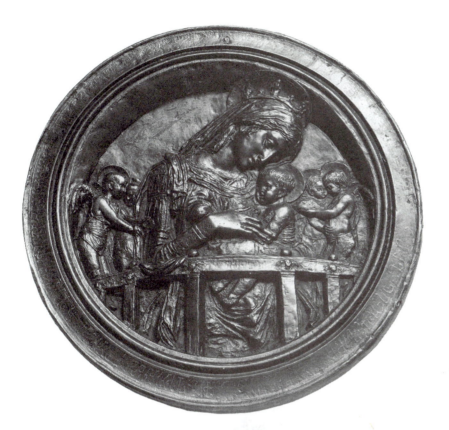

67. (*Above*) Donatello, *The Virgin and Child with Four Angels ("Chellini Madonna")*, before 1456. Victoria and Albert Museum, London

68. (*Right*) Antonio Rossellino, *Dr. Giovanni Chellini*, 1456. Victoria and Albert Museum, London

After being lost to view for centuries, Dr. Chellini's bronze roundel turned up recently in an English country house, having been purchased in 1764 at an auction in London of an old Florentine art collection.

It is in the form of a thick bronze dish, the size of a dinner plate: it has a slightly concave rim which makes it easy to hold, while in the bowl Donatello has modeled a scene of the Virgin Mary holding the newborn Jesus to her, attended by baby angels, all behind a railing. We see them through a circular hole like those in the Old Sacristy at San Lorenzo: our viewpoint is low, for we cannot see the thickness of the lower ledge of the pretense architecture, only the crescent above the participants. The design and background are picked out in gilding to make the figures more legible, as well as to look more precious. The back of the roundel is hollowed out with an exact negative image of the figures on the front, and this unique feature enables us to connect it positively with the item that Donatello gave to his doctor.

It has proved possible, with great manual skill, to cast in glass replicas from Donatello's mold—and very satisfactory they are too. The glassmaker had to drop his load of glutinous, molten glass off the end of his iron rod exactly in the middle of the disk, so that it spread out centrifugally to cover the whole surface before solidifying. These replicas could have been used to glaze small bull's-eye windows, such as were a feature of Renaissance architecture. Seen from within, with the sunlight shining through, they would have given a shimmering, evanescent vision of the Virgin and Child, as though appearing from heaven.

Donatello's earlier *Madonnas* have been discussed. Probably he went on creating new variants as the mood took him and to oblige his patrons all through his life. It is difficult however to assign dates to the several types that seem to be his handiwork, for positive points of stylistic reference among his datable sculptures are hard to find. One of the most beautiful— and certainly original—versions is a gilded terracotta in the Victoria and Albert Museum [69]. It shows the same characters as the Chellini roundel writ large—indeed they are over life-size: the same exquisitely featured Virgin with long, gentle fingers; the same Christ Child with the anatomically accurate bulge to the back of the skull, which is typical of a newly born baby. Only this time he is propped up tightly swaddled on a simple wooden chair, like a doll, while his young mother stares gently at him in a reverie. Nevertheless its date remains to be firmly established. Closely related to both these Madonnas is a marble one now in the Museo dell' Opera del Duomo and formerly over a side porch of Siena cathedral, but

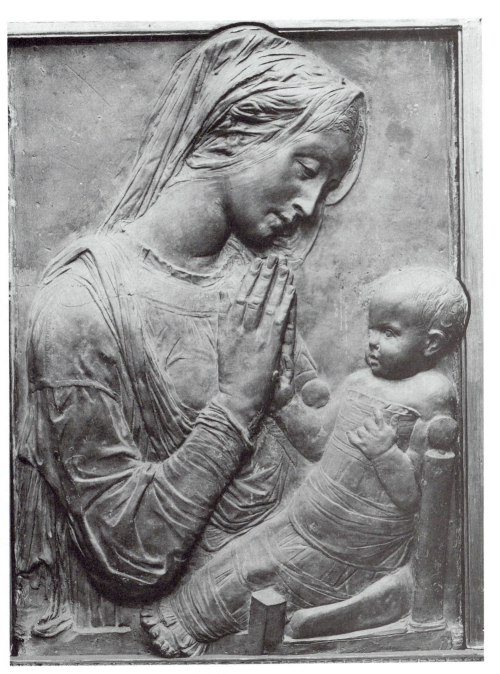

69. Donatello, *The Virgin and Child*, 1450s?
Victoria and Albert Museum, London

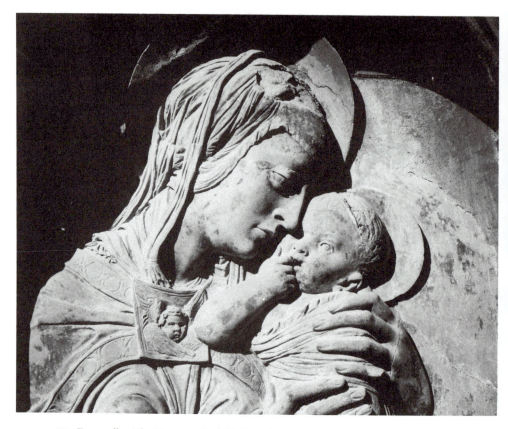

70. Donatello, *The Virgin and Child ("Madonna of Via Pietrapiana"),* 1450s?
Detail. Tabernacle on Via Pietrapiana, Florence

which was once above an altar inside. This was carved in 1457, largely by
Donatello's assistants, but it must have been designed by him while he was
briefly engaged on designing the bronze doors for the cathedral, which he
failed to complete. It is based on the idea of the Chellini roundel; the group
is shown as though protruding through a large porthole in the actual
structure of the building.

In 1985 I discovered another original *Madonna* modeled in terracotta
in a street tabernacle in Via Pietrapiana in Florence [70]. The particular
composition has long been associated with Donatello and is known by the
particular street name, but it had never been properly examined to deter-
mine if it were original, or just one of the several known cast copies. In fact
the modeling of forms and delicacy of detailing proclaim it as an autograph
work by the sculptor.

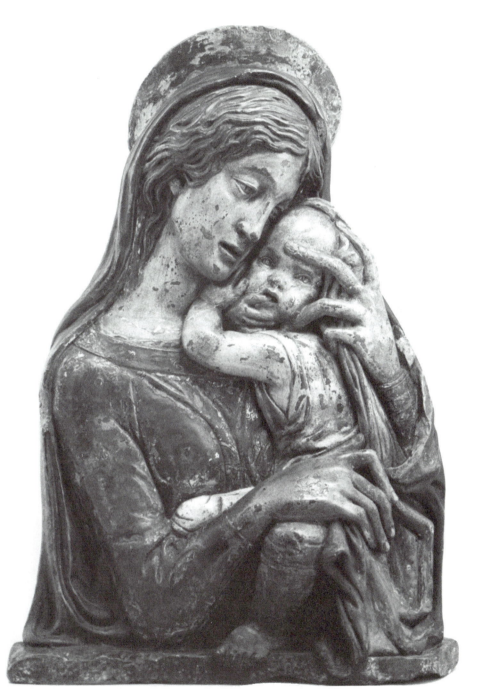

71. After Donatello, *The Virgin and Child ("Verona Madonna")*, c. 1450.
Michael Hall Fine Arts, New York

Many other versions of this central theme of Christianity by Donatello are known, some only in casts of which the original is apparently lost, for example a well-known *Madonna* named after the city where one good version is known—Verona [71]. Casts of *Madonnas* designed by Donatello are now spread worldwide thanks to nineteenth- and twentieth-century art collecting.

Two years after Donatello gave his doctor the bronze roundel and when he was in Siena, he was reported to be very ill again and was bought a new bed by the town council. Obviously his three score years and ten were beginning to take their toll. The most likely occupation for the three undocumented years between 1454 and 1457—and probably the reason why Donatello abandoned those lucrative invitations to work for other princes—was the decoration of the Medici palace [72]. The architecture of the palace is probably the work of his former partner, Michelozzo, and so this was a perfect opening for the elderly Donatello. After a ten-year campaign of building operations, some incised fresco decorations had finally been executed in 1452 around the courtyard arcade by Maso di Bartolommeo, who was also a former associate of Donatello on the Prato pulpit.

Just as Brunelleschi's rather plain Renaissance architecture in the Old Sacristy was embellished with relief sculpture supplying Christian imagery, so the courtyard of the palace was to be given a specifically humanist message, in tune with the interests of Cosimo and his friends, the Neoplatonic philosophers and professors of Greek and Latin, for whom the Medici had founded the Platonic Academy at their villa of Careggi.

Each side of the courtyard has three arches and above them are three large roundels: the central ones have traditional heraldic devices, as in a medieval castle, but the eight flanking fields contain greatly enlarged versions of eight famous ancient cameos, most of which were in the Medici collections: this was a highly original idea characteristic of Cosimo and the artists he inspired. The style in which they are carved is Michelozzo's, though they may have been executed by his faithful assistant, Pagno di Lapo, who had also worked on the Prato pulpit. The roundels represent thematically the origins and development of man; four of them also exemplify the cardinal virtues.

It is in the context of these roundels that the keystone of the whole intellectual program may best be understood. For in the courtyard—either in the center, or perhaps where Bandinelli's *Orpheus* now is sheltered under the central arch of the further arcade—once stood Donatello's

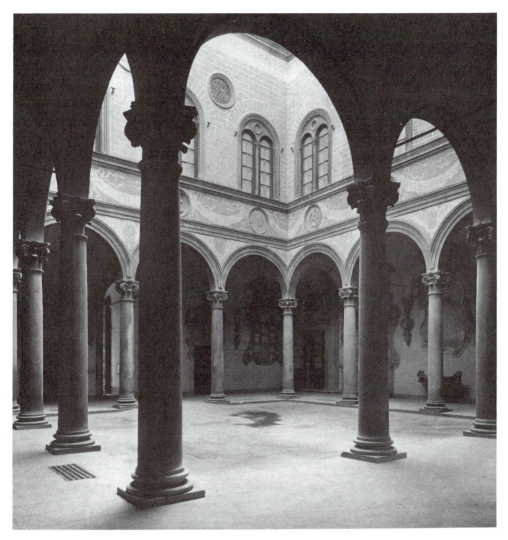

72. Michelozzo and Pagno di Lapo, Courtyard of the Medici-Riccardi Palace, c. 1452. Florence

bronze *David,* which is now high and dry in the Museo Nazionale del Bargello and thus nigh incomprehensible [73–75]!

The near-nudity, the deliberately sensual interpretation of the lithe male body and the mood of dreamy contemplation have always been puzzling: for they are all at variance with the Old Testament story of David the shepherd boy and Goliath his gigantic foe. The figure is of course derived from Greco-Roman statues of nude athletes, and is indeed the first life-size nude statue of the Renaissance, if one excludes Donatello's own recent *Crucifix* in Padua. This avant-garde sculpture resulted from a deep understanding between the artist and his patron; it was a private commission, for display in a private palace—though it would have been intriguingly visible through the great entrance arch from the street to every passerby, as well as to anyone who had business in the palace.

The most likely explanation of Donatello's interpretation is that the statue was to be read by those familiar with Plato's writings as not just an Old Testament hero, but as an allegory of heavenly love. The relief on Goliath's visor is based on one of the same cameos as one of the roundels in the courtyard of the palace: it represents the triumph of platonic love and shows Eros—or Cupid—enthroned on a chariot drawn by other winged infants. A description of Eros in Plato's *Symposium* may have been read to Donatello, for it provides all the ideas that are *not* present in the Bible story: "Eros is young, and he is also tender . . . of a truth he is the tenderest as well as the youngest and also he is of flexible form . . . and a proof of his flexibility and symmetry of form is his grace. The beauty of his complexion is revealed by his habitation among the flowers . . . in the place of the flowers and scents, there he sits and abides. . . ." Just as this interpretation of David seems strange to us, not being well versed in Platonic philosophy, so it must have mystified, and perhaps shocked, the majority of those who saw it. Perhaps this is why some years later Lorenzo de' Medici commissioned from Donatello's successor as "house sculptor," Verrocchio, another, more traditional and less disturbing bronze statue of the subject: Verrocchio's *David* is a wiry Tuscan youth, sensibly clad in a leather breastplate and kilt, his muscles still tensed from the action of stoning and then beheading his adversary.

Also for the Medici palace, but to decorate a fountain in its enclosed back garden, Donatello created another major bronze group, *Judith and Holofernes* [76]. It was confiscated by the Florentine government when the Medici were expelled in 1494 and reerected in the Piazza della Signoria, out of context like the *David.* It has recently been taken inside for the sake

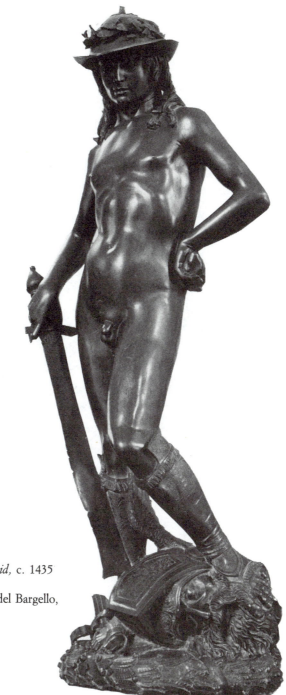

73. Donatello, *David,* c. 1435
or c. 1453.
Museo Nazionale del Bargello,
Florence

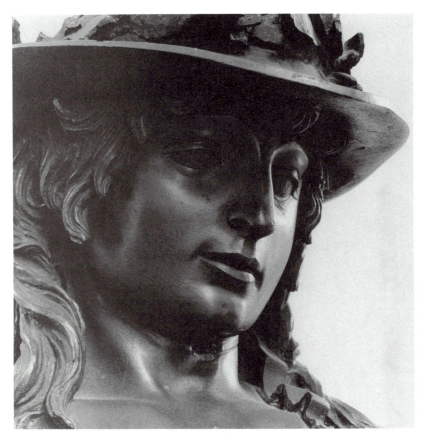

74. (*Above*) Donatello, *David*. Detail of the face

75. (*Right*) Donatello, *David*. Detail of Goliath's head

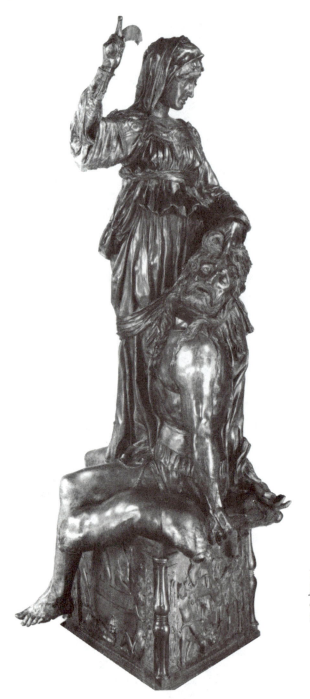

76. Donatello,
Judith and Holofernes,
c. 1455. Palazzo della
Signoria, Florence

of conservation. An inscription once below it ended: "behold the neck of pride severed by the hand of humility." The Old Testament story provided a neat parallel to that of David, by substituting as a heroine an attractive Hebrew widow who had seduced an enemy of Israel in order to get him drunk and kill him. There is already a gash on his neck and Judith holds aloft Holofernes' own saber for a second, fatal blow, as though she were about to sacrifice an animal. Both figures are set on a cushion, presumably to symbolize the couch in Holofernes' tent: the motif of a cushion, crushed as though by the weight of the figures, recalls Donatello's earlier *St. Mark* on the guildhall. However, it also doubles as a kind of wineskin, to recall Holofernes' drunkenness, for its four corners have spouts in their tassels to emit real water into the fountain basin below.

Neither the *David* nor the *Judith* can be dated by documents: indeed the *David* has often been allocated to the period when Donatello was working for the Medici *before* he left for Padua. However, it could not then have been made specifically for the palace courtyard, for this had not been built by that time: it is also doubtful that Neoplatonic thought had advanced enough before the 1450s to have inspired Donatello's peculiar rendering. In 1456 he is recorded as purchasing a quantity of wax, iron and bronze, all materials for making bronze statuary, and this may have been for the *Judith* and the *David,* as well as a bronze *St. John the Baptist,* which he cast for Siena cathedral late in 1457 [77]. The *Judith* conforms well in type and style with Donatello's other harrowing images of saints.

The intended location of the St. John within the cathedral is not known, although it may have been for the Baptistery, near the font to which Donatello had contributed in the 1420s. It was modeled and cast in three sections, with the right forearm separate too: in September and October 1457 the components were received in Siena, but the forearm was still missing. The story goes that Donatello held it back because he was dissatisfied with the payments he had received from the Sienese. Such an act is perfectly consistent with what we know of his character, and one can see that the present forearm is not properly fitted on at the elbow. The abrupt modeling and stylization of forms in the head recalls the *St. Francis* in Padua, while the tumbling hair, which resembles fraying rope, and the curly goat's fleece reflect the ease and rapidity of modeling in wax, prior to casting in bronze. Unless it was intended for a niche from the outset, it is strange that Donatello treated this statue as a columnar figure, as though carved out of a tree trunk, like his earlier *St. John* for Venice or the nearly contemporary *St. Mary Magdalene.* For as he was using bronze, he

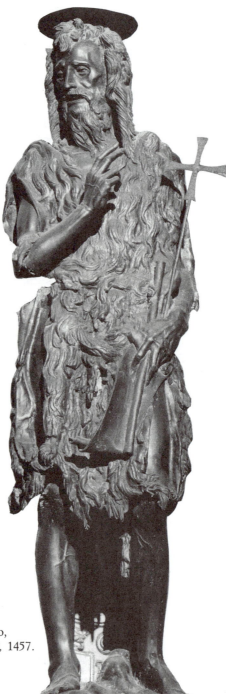

77. Donatello,
assisted by Bellano,
St. John the Baptist, 1457.
Cathedral, Siena

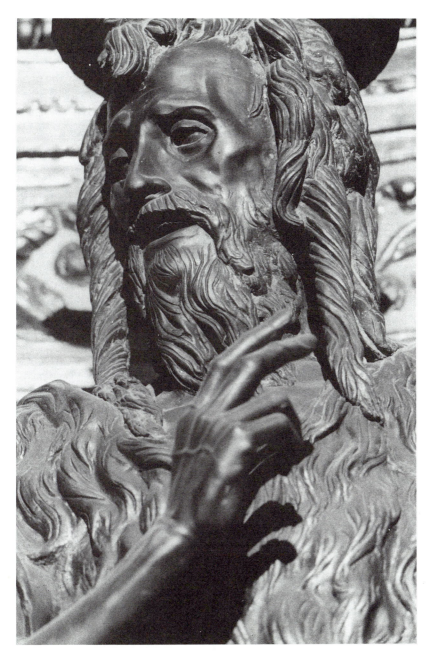

78. Donatello, *St. John the Baptist*. Detail of the head

could have exploited its tensile strength to allow the limbs to project into the surrounding space as freely as he chose. The saint's appearance here is no longer as benign as in the earlier, wooden version [78]. This is partly because of the dark color of the bronze and partly because of the uncompromising freedom which the aging sculptor allowed his own imagination in summoning up the savage appearance of the prophet. The statue is unlike anything seen hitherto during the Renaissance and seems not to have been put on display for years, probably because its imagery was regarded as outrageous.

Closely connected in its shocking appearance and evident depths of feeling is Donatello's imaginary "portrait"—for she must be studied from the life—of St. Mary Magdalene [79; Plate II]. Though undocumented, the statue is normally held to date from the last decade of the sculptor's life. It was carved in wood, but much of the detail was added by modeling pliable materials on its surface. The final touch of realism was given by painting. At first glance the image is horrific: the wizened face with cheeks and eyes sunken and the emaciated limbs, all covered with a tanned and leathery skin, remind us of an Egyptian mummy. But to a Christian, the message is not pessimistic. Through the deliberate starvation and hardships to which Mary Magdalene has subjected her body, originally an object of physical desire, her spirit has been strengthened and ennobled. Donatello deliberately stressed the blue eyes, golden hair and fine bone structure of a creature who had once been glamorous: the victory of the human spirit over the flesh is the message that the aged sculptor intended to convey. Nevertheless, such a statue must have been an affront to the sensibilities of the Florentine public.

From 1457 to 1459, following his production of the *St. John* in bronze, Donatello moved to Siena, and made preparations to produce a monumental pair of bronze doors for the western portal of Siena cathedral. Nothing remains in Siena, and only the *Lamentation,* a bronze relief now in London, and the *Massacre of the Innocents,* a drawing in Rennes, are ever connected with this ill-fated project [80; 81]. It no doubt would have contained an impassioned critique of the *Gates of Paradise,* which had been unveiled in Florence in 1452 and whose creator, his old rival Ghiberti, had died in 1455. Donatello's own smaller doors for the Old Sacristy, his bronze reliefs for St. Anthony's in Padua and those that he was to produce from his deathbed in Florence for San Lorenzo give an indication of what the Siena doors might have looked like. Why Donatello should have abandoned the remunerative position that he enjoyed at Siena while making the models

79. Donatello,
St. Mary Magdalene, 1454.
Museo dell' Opera
del Duomo, Florence

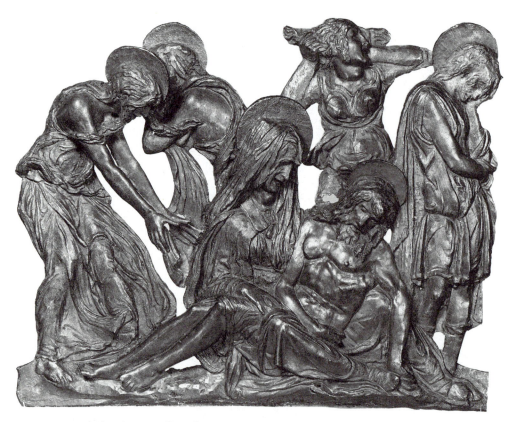

80. (*Above*) Donatello, *The Lamentation,* c. 1457–1459.
Victoria and Albert Museum, London

81. (*Right*) Attributed to Donatello, *The Massacre of the Innocents,* c. 1457?
Musée des Beaux-Arts, Rennes

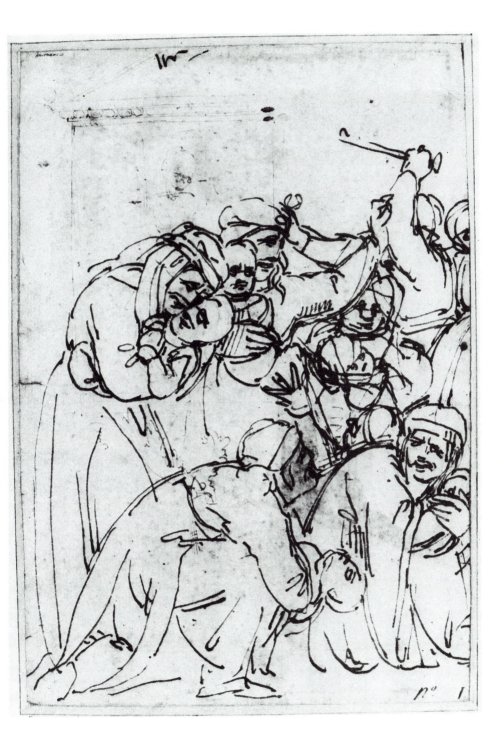

82. Donatello and Bellano, *The Crucifixion and the Deposition*.
Detail of the South Pulpit, c. 1466. San Lorenzo, Florence

83. Donatello and assistants, North Pulpit, 1464–1465. San Lorenzo, Florence

for the doors is not known. A story that he was tempted back to Florence purely out of civic chauvinism does not ring true. Possibly it was the increasing illnesses of old age from which he was suffering that engendered a wish to die at home; or perhaps there was some dispute over his avant-garde style that was not acceptable to the Sienese; or—quite probably—it was once again Cosimo de' Medici, the presiding genius of the sculptor's career, sensing his own approaching end, who encouraged him to leave Siena.

We know that Donatello was back in Florence by June 1459, for the cathedral Board of Works paid his rent for a house on the present-day Via Ricasoli. This document gives substance to Vasari's account of Donatello's last illness and eventual death in what he described as "a poor little house in Via del Cocomero [Cucumber Road]"—for this was the name of one stretch of the present street.

Perhaps there is a connection between the apparently total disappearance of three years' work at Siena on a project involving a number of narrative panels in relief—which might well have depicted the New Testament—and Donatello's last great commission for the Medici, which saw him to the grave. This was a pair of bronze pulpits showing the Passion of Christ for their parish church of San Lorenzo [82; 83].

Vespasiano da Bisticci in his biography of Cosimo referred to a "lack of employment" in sculpture that encouraged him to commission the bronze pulpits from Donatello. This is mystifying, for there was in fact no dearth of commissions for sculptors in general in the middle of the fifteenth century, indeed quite the opposite. Might this not have been a tactful way of expressing the fact that Donatello's late style—which so much appeals to the twentieth-century viewer—was not appreciated at the time, so that he found himself without work, apart from the one patron who was attuned to his increasingly idiosyncratic personal style? Cosimo could then be seen as having stepped in to save face for the elderly sculptor by paying for the production in bronze of his last great work. Even so, the curious fact is that the reliefs were put into storage and not erected until the High Renaissance. The clear implication is that they were not popular with Piero the Gouty, Cosimo's successor, whose taste indeed tended more toward classical and decorative art forms.

On the south pulpit, the conception of space is straightforward: two great rectangular scenes are simply divided by pilasters, in front of which figures were placed, as in the interior scenes of the miracles of St. Anthony [82]. The narrative takes place mostly in pretense depths behind these pilasters, apart from a few overlapping figures right in the foreground. This treatment is close to what might have been expected on the doors of Siena cathedral, and the dimensions of these panels do correspond with the width of the doors. These designs may have already existed in the form of wax models, such as Donatello was paid for by the Sienese. Part of Donatello's series of reliefs for Siena may thus have been indirectly saved by Cosimo de' Medici, who—unfortunately for Donatello—died in 1464.

However, on the north pulpit in San Lorenzo—which Donatello lived to see completed, judging from the date June 15, 1465, engraved on it—the scenes from after the Crucifixion are divided by protruding buttresses, in a way that would not have worked on a pair of doors [83]. This has given rise to an interesting suggestion that these reliefs may have been intended to run around an elaborate tomb for Cosimo. There is no contemporary written evidence for this, but it is mentioned by Vasari.

The front is divided by the buttresses into three sections (and not

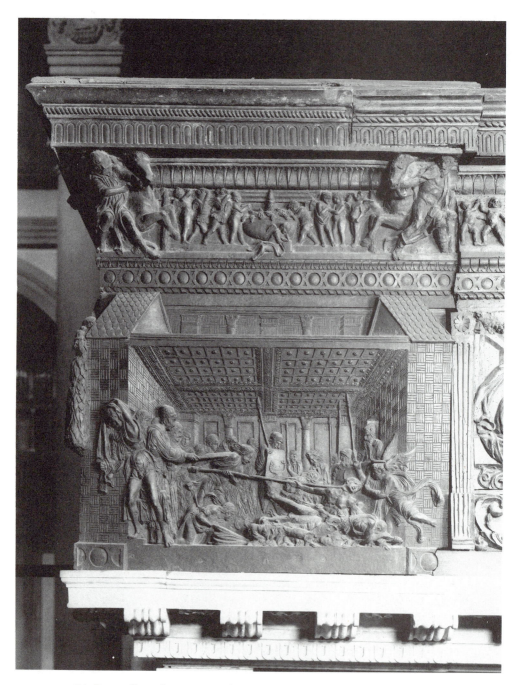

84. Donatello and assistants, *The Martyrdom of St. Lawrence.*
Detail of the North Pulpit

two, as on the other pulpit) showing *Christ in Limbo,* the *Resurrection* and *Christ Appearing to the Apostles.* The style of the figures is a still more violent variation on that of the reliefs at Padua: the smoothness of naked limbs is set off against crumpled drapery or shaggy hair. The rear planes do not open into cavernous architectural depths as in the scenes in St. Anthony's, but press forward behind the groups of figures, seeming to make them protrude into the space of the real world. In particular, the scene of the *Resurrection* is quite unorthodox: the figure of Christ rising in his shroud like a ghost from one end of the tomb is deliberately unlike the standard, idealized nearly nude male figure, which traditionally stood at the center of the composition. Many traces can be found in the bronze of the original wax surface modeled by Donatello, although most of the cold-chiseling is probably the work of his helpers, as he was too old and ill to undertake such strenuous physical labor.

On the back of this pulpit is a remarkable scene of the *Martyrdom of St. Lawrence,* gruesome because of a realism with which only Donatello knew how to imbue a scene of torture [84]. It is dominated by the diagonal thrust of the long fork with which the saint is being held down on the roasting grid. The second corpse appearing alongside is also not traditional and may be a way of indicating the saint's death, by continuous narration.

Whether or not Donatello was on his deathbed, the reliefs look as though they were left rough and unfinished deliberately, as a means of expression. This is not the fumbling of senility—no, it is the culmination of a lifetime's practice in revitalizing all too familiar narrative scenes by identifying personally with the participants and reliving their experiences. Donatello had spent seventy years mastering the problems of "making people's faces come to life" and by now he could even capture fleeting emotions. An abstraction of forms is inherent in his bold initial modeling of wax and his free approach to chiseling the cold metal. The use of space has become on occasion completely arbitrary. Nothing like this would be seen again until the twentieth century.

Vasari relates a touching tale about the provisions that Cosimo made about 1464 for the sculptor's old age: "Donatello passed his old age most joyously, and, having become decrepit, he had to be succored by Cosimo and by others of his friends, being no longer able to work. It is said that Cosimo, being at the point of death, recommended him to the care of his son Piero, who, as a most diligent executor of his father's wishes, gave him a farm at Cafaggiuolo, which produced enough to enable him to live in comfort. At this Donatello made great rejoicing, thinking that he was thus

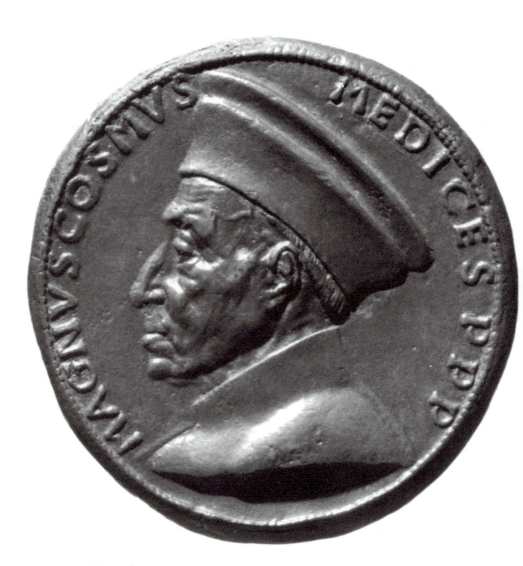

85. Donatello(?), *Cosimo de' Medici as Pater Patriae*, 1465.
Victoria and Albert Museum, London

more than secure from the danger of dying from hunger; but he had not held it a year before he returned it to Piero and gave it back to him by public contract, declaring that he refused to lose his peace of mind by having to think of household cares and listen to the importunity of the peasant, who kept pestering him every third day—now because the wind had unroofed his dovecote, now because his cattle had been seized by the Commune for taxes, and now because a storm had robbed him of his wine and his fruit. He was so weary and disgusted with all this that he would rather die of hunger than have to think of so many things. Piero laughed at the simplicity of Donatello; and in order to deliver him from this torment, he accepted the farm (for on this Donatello insisted), and assigned him an allowance of the same value or more from his own bank, to be paid in cash, which was handed over to him every week in the due proportion owing to him; whereby he was greatly contented."

Used to the hubbub of life in the metropolis of Florence and dedicated solely to his all-absorbing artistic pursuits, retirement to the country—peaceful or the opposite—was not for this crotchety old bohemian! The old sculptor's gratitude to his life-long patron found expression in a brilliantly modeled portrait profile for a commemorative medal, which was cast soon after Cosimo's death [85]. The deliberate distortions of the aged physiognomy to catch light and form shadows—and thus to animate the face—are unique to Donatello's late relief style. No medalist of the period could have achieved this brilliantly sculpted portrait in miniature.

Vasari continues the story of the sculptor's old age with an anecdote that must be true, so well does it fit with what we have learned of his character: "A little before his death, he being sick, some of his relations went to visit him, and after the usual salute and consolations they told him that it was his duty to leave them a farm which he had in Prato, small though it was, and of little value, and they prayed him most earnestly to do so. Donatello, who was just in all his dealings, when he had heard them, replied: 'I cannot content you, O my kinsmen, because I desire, and it seems to be reasonable to leave it to the farmer who has always worked it, and suffered much fatigue with it, and not to you, who have done nothing to obtain it but pay me this visit. Go in peace. . . .' Then having sent for the notary he bequeathed the farm to the peasant who had always worked it. This was the smallholding at Figline that he had purchased twenty odd years before, in 1443. It was with ill-disguised satisfaction that he disappointed his pressing relatives of their hopes, in favor of his faithful old retainer.

"When he had reached the age of eighty-three," Vasari concludes, "he was so palsied that he could no longer work in any fashion, and took to spending all his time in bed in a poor little house that he had in the Via del Cocomero, near the Nunnery of S. Niccolò; where, growing worse from day to day and wasting away little by little, he died on 13 December 1466. He was buried in the Church of S. Lorenzo, near the tomb of Cosimo, as he had himself directed, to the end that his dead body might be near him, even as he had been ever near him in spirit when alive." This would be a signal honor for an artist in any period, and was without parallel in the Renaissance.

Donatello's late style, with its amazing boldness of imagination and execution, derived from a long lifetime's experience, probably overawed the Florentines and seemed incomprehensible and inaccessible. They had been seduced by the sweet style of Ghiberti, Luca della Robbia and the Rossellino brothers, which had held sway ever since Donatello left for Padua in 1443. A statue such as his *Mary Magdalene* must have seemed an affront to their sensibilities, if not to their beliefs. The mood of Donatello's last offerings predicted the preaching of the fanatical Dominican monk Savonarola, later in the century, who warned the Florentines against the pleasures and luxuries of the worldly life and recommended them to penitence and abstinence.

Donatello's statements are so singular and so sincere that they secure him a place among the great artists of all time, who transcend the epoch in which they live and speak to men in every age.

Chronology

Entries in brackets are speculative.

1386
Probable date of birth in Florence, son of Niccolò di Betto Bardi, wool-carder. (Calculated from tax declarations in 1427, when he claimed to be 40, and in 1433, when he claimed to be 47.)

1401
Pistoia, where he had struck a German with a stick and drawn blood.

[1402–1404]
According to Vasari, first visit to Rome with Brunelleschi, who had just lost the competition over the bronze doors for the Baptistery in Florence to Ghiberti.

1404–1407
Working in Ghiberti's shop on the modeling stages for his first set of doors.

1406
Payment is received for "marble prophets," designed for Porta della Mandorla, Florence cathedral.

1408
Commissioned to carve a *David* to go on a buttress of Florence cathedral; completed in 1409. Commissioned to carve *St. John the Evangelist* for the west front of the cathedral (finished 1415).

1410–1412
Payments received for a terracotta colossal statue of Joshua for a buttress of the cathedral.

1411
The Linen Drapers' Guild commissions the *St. Mark* for their niche on Orsanmichele (finished 1413).

1412
Matriculates in the Guild of St. Luke as a "goldsmith and stone-carver."

1415
Paid with Brunelleschi for a "small figure of stone, clad in gilt lead," which served as a model for further figures to go on the buttresses.

1415

December: two marble statues of prophets for the Campanile are commissioned (finished 1418 and 1420 respectively).

1416

The city council (Signoria) acquires from the Board of Works of Florence cathedral a marble *David* for installation in the city hall (Palazzo della Signoria): it was to be elaborately painted and gilded, with a base inset with mosaic.

1417

The Guild of Armorers buys a block of marble for the base of their *St. George* on Orsanmichele [possibly for carving the shallow relief of *St. George and the Dragon:* in any case, the document tends to imply that the statue was finished].

1418

Carves the heraldic lion of Florence (Marzocco) for the newel post of a stairway in the new papal apartments in the Monastery of Santa Maria Novella (finished 1420). [Probably began the gilt-bronze *St. Louis* for the niche of the Guelph Party on Orsanmichele].

1418–1419

With Brunelleschi and Nanni di Banco produces a model in brick and cement for the dome of Florence cathedral.

1421

Carves with Nanni di Bartolo the group of *Abraham and Isaac* for the Campanile.

1421–1426

Rents a house from the Frescobaldi next to their palace.

1422

Completion of the niche for *St. Louis* on Orsanmichele in Florence. Receives payment for reliefs of "two heads of prophets" on the Porta della Mandorla [probable date of the stylistically analogous relief of the Virgin and Child now in Berlin-Dahlem Museum].

Discussions over nature and location of the tomb of the antipope John XXIII in the Baptistery.

1423

Receives payment for a statue for the Campanile, probably *Jeremiah.* Commissioned by the Board of Works of Orvieto cathedral to make a gilt-bronze statuette of St. John the Baptist for the font (not identified). Commissioned by Siena cathedral to manufacture a bronze relief of the *Feast of Herod* for the font (finished by 1425, delivered 1427).

1425–1426

Goes into partnership with Michelozzo di Bartolommeo, probably in connection with a commission for the tomb of the antipope John XXIII in the baptistery (completed about 1428). The partnership lasts until about 1433. Donatello's workshop is now in Corso degli Adimari, south of the cathedral. Payments from the Medici branch bank prove that Donatello was in Pisa,

probably acquiring marble from the nearby quarries of Carrara, for the tombs of John XXIII and Cardinal Brancacci for Naples.

1426

Documented contact with Masaccio, who was also working in Pisa. Probable date of certain shallow reliefs (e.g., the *Assumption* for Naples and the oval *Virgin and Child*). A statue for the Campanile, probably *Jeremiah*, is finished.

1427

Receives payment for another statue for the Campanile, probably *Habbakuk*. Date on the signed bronze tomb slab for Bishop Giovanni Pecci in Siena cathedral. First tax return (*Portata al Catasto*) of the partners, written out by Michelozzo, declares work on the gilt-bronze *San Rossore* for the convent of Ognissanti in Florence; tomb of John XXIII three-quarters complete; tomb of Cardinal Brancacci one-quarter complete; Aragazzi monument for Montepulciano in hand; marble figure, probably *Habbakuk*, three-quarters complete.

1428

Receives payment for the two bronze statuettes *Faith* and *Hope* for the Siena font. Contract for the exterior pulpit on Prato cathedral (finished 1438).

1429

Models three *putti* for the Siena font.

1430

Engages with Brunelleschi on military preparations outside Lucca.
Goes to Rome with Michelozzo.

1432

Executes the tomb slab for Giovanni Crivelli, archdeacon of Aquileia (in Santa Maria in Aracoeli).
[Executes the *Tabernacle of the Blessed Sacrament* for St. Peter's.]
Letter between the Medici and Prato authorities about persuading him to return from Rome and finish the pulpit; Pagno di Lapo, his assistant, is sent to Rome to fetch him.

1433

Submits his tax return. The Medici rent him the former inn of Santa Caterina for working premises (until 1443) [Models the reliefs in the Old Sacristy of San Lorenzo.]
The *Singing Gallery* for Florence cathedral commissioned and marble obtained.
The bronze capital for the Prato pulpit is begun; carving of the marble panels continues until 1438.

1434

His design for a stained glass window in the cathedral showing the Coronation of the Virgin is chosen instead of Ghiberti's (finished by 1437).
He and Luca della Robbia each make a model in terracotta for a colossal head for the top of the dome in Florence cathedral.
Bronze door for the tabernacle on Siena font is rejected by the Sienese.

1435
[Date of execution of the Cavalcanti *Annunciation*]
1436
Habbakuk is finished and paid for.
1437
Bronze doors for sacristy of Florence cathedral are commissioned though never executed by Donatello.
1438
Date inscribed on the painted wood *St. John the Baptist* in the church of the Frari, Venice. Prato pulpit finished.
1439
Makes a wax model for an altar of St. Paul in Florence cathedral, to be carved in marble by Luca della Robbia. Bronze heads cast and gilded, to go beneath his *Singing Gallery,* which was thus completed.
1443
Buys a house at Figline near Prato. Moves to Padua.
1444
Starts work on the bronze *Crucifix* (finished 1449).
1445
Briefly returns to Florence, estimating with Luca della Robbia Il Buggiano's *Lavabo* in the cathedral sacristy. Commission for the bronze doors is transferred to Michelozzo and Luca della Robbia.
1446
Bequest of Francesco Tergola for the high altar of the Basilica of St. Anthony, Padua; Donatello assembles his team of craftsmen.
1447
Panels of *Angels, Evangelists* and *Miracles of St. Anthony* are modelled, cast and chased. *St. Louis* and *St. Francis* begun. *Monument to Gattamelata* commissioned (finished 1453).
1443
All the *Saints* and the *Virgin and Child* cast. Temporary altar in wood erected to demonstrate the appearance for the feast of St. Anthony (13 June). Marble altar then begun.
1449
Entombment relief paid for. *Pietà* relief produced.
1450
The statues definitively installed on the high altar. Legal proceedings against Petruccio, over a lapsed commission for a chapel. Seven items sent to Mantua for Lodovico Gonzaga and Barbara of Brandenburg. Negotiations over a statue of Borso d'Este for Modena (not finished).
1451
Payment from the Bishop of Ferrara; further work for Modena; correspondence with Lodovico Gonzaga about a casket of St. Anselm (never executed).

1452
Alfonso of Aragon, King of Naples, writes to the Venetian government in an attempt to obtain Donatello's services.

1453
Valuation of the *Monument to Gattamelata*.

1454
Rents a house and shop on Piazza del Duomo in Florence.

1455
[Possible date of execution of the *St. Mary Magdalene*.]
Dispute with Prato authorities over payment outstanding on the pulpit.

1456
Gives bronze roundel of the *Virgin and Child* to his doctor, Giovanni Chellini, in lieu of a medical fee for attendance during a protracted illness. Purchases materials for casting bronze statuary. Bartolomeo Bellano from Padua is an assistant. Begins work for the Board of Works of Siena Cathedral, possibly on the bronze *St. John the Baptist* for the Baptistery.

1457
Moves to Siena; is paid for *St. John;* to work on the chapel of Nostra Donna della Grazie (previously allocated to Urbano da Cortona). Begins wax models for the west doors of Siena cathedral—work continues until 1459.

1458
Lodovico Gonzaga tries in vain to obtain Donatello's services from the Sienese.

1459
Returns to Florence, renting a house on "via del Cocomero" (via Ricasoli today).
[Probably produces *Judith and Holofernes* and bronze *Pulpits* in San Lorenzo for the Medici.]

1461
Paid for work on the *Chapel of the Annunziata* in that church by Piero de' Medici.

1464
Death of Cosimo de' Medici; [Donatello probably models his portrait for a medal].

1465
15 June, date on the relief of the *Martyrdom of San Lorenzo* on the North Pulpit of San Lorenzo.

1466
10/13 December, dies, leaving *Pulpits* unfinished. Buried ceremoniously, near Cosimo de' Medici, in the crypt of San Lorenzo.

Locations of Donatello's Sculptures

Numbers in parentheses are museum inventory numbers.

Armenia

YEREVAN
Art Gallery
(on deposit from the State Hermitage, St. Petersburg) (with Michelozzo)
Virgin and Child, marble relief

Austria

VIENNA
Kunsthistorisches Museum
The Virgin of Humility, gilt bronze medallion (P1.7642)
The Virgin and Child on a Balcony, terracotta relief (Ps.9101)

France

LILLE
Musée des Beaux-Arts
The Feast of Herod, marble relief

PARIS
Musée Jacquemart-André
A pair of candle-bearing putti, bronze (1733)
Musée du Louvre
The Virgin and Child, painted and gilt terracotta relief (704)
The Crucifixion, bronze plaque (Bequest of Count Isaac de Camondo, 1911)

(After Donatello, possibly by Michelozzo)
The Piot Madonna, circular terracotta relief (710)

(After Donatello, later aftercast of lost relief)
The Virgin and Child from Fontainebleau, bronze relief (712)

RENNES
Musée des Beaux-Arts
The Massacre of the Innocents; David Triumphant, drawing (794.1.2501)

Germany

BERLIN-DAHLEM
Staatliche Museen Preussischer Kulturbesitz
Virgin and Child (so-called "Pazzi Madonna"), marble relief (51)
Putto with Tambourine, bronze statuette (2653)
David with the Head of Goliath, bronze statuette (2262)
Bode Museum
Virgin and Swaddled Child, terracotta relief, formerly painted
(After Donatello)
The Orlandini Madonna, marble relief

Great Britain

LONDON
Victoria and Albert Museum
The Virgin and Child with Four Angels, marble relief (A.98-1956)
The Ascension of Christ, marble relief (7629-1861)
The Dead Christ Tended by Angels, marble relief (7577-1861)
The Lamentation over the Dead Christ, bronze relief (8552-1863)
Winged Putto with a Dolphin, bronze fountain (475-1864)
The Chellini Madonna, bronze roundel (A.1-1976)
The Virgin Adoring the Child, terracotta relief (57-1867)
The Flagellation and Crucifixion, terracotta relief (7619-1861)

(After Donatello)
The Virgin and Child, marble relief (8376-1863)
The Virgin and Child with Five Angels, marble relief (7624-1861)
The Virgin and Child, bronze plaquette (7474-1861; 5473-1859)
The Virgin and Child in a Shell Niche, bronze plaquette (4080-1857; A406-1910)

The Virgin and Child, painted stucco (A.45-1926)
The Virgin and Child before an Arch, painted stucco (7385-1861)
St. George and the Dragon, stucco (7607-1861)
The Verona Madonna, stucco (A.1-1932)
The Virgin and Child with Two Saints and Two Angels, painted stucco
(93-1882)
Wallace Collection
The Virgin and Child before an Arch, with a Vase, bronze plaque (S.297)

OXFORD
Ashmolean Museum
(Attrib.) The Entombment, bronze plaque

Hungary

BUDAPEST
Museum of Fine Arts
(Attrib. to Michelozzo)
Virgin and Child, terracotta relief (1170)

Italy

AREZZO
Cathedral
The Baptism of Christ, marble relief on font

BOSCO AI FRATI (MUGELLO)
San Francesco
(Attrib.) Crucifix, painted wood statue

FAENZA
Pinacoteca
St. Jerome, painted wood statue

FLORENCE
Cathedral
Prophets, marble relief (left and right of gable of the Porta della Mandorla)
Museo dell' Opera del Duomo
St. John the Evangelist, marble statue
Abraham and Isaac, marble statue
Beardless Prophet, marble statue
Bearded Prophet, marble statue
Jeremiah, marble statue
Habbakuk, marble statue
St. Mary Magdalene, painted wood statue
Singing Gallery, marble structure and reliefs
Church of Orsanmichele
St. George, marble statue (copy: original in Bargello)
St. George and Dragon, relief (copy: original in Bargello)
Niche of Armorers' Guild, with marble relief of God the Father in gable.
St. Mark (copy)
Niche of the Guelph party (east side, containing Verrocchio's bronze group
 of Christ and St. Thomas)
Church of San Lorenzo
Pair of bronze pulpits (in the nave)
Reliefs of the life of St. John the Evangelist (in the Old Sacristy)
Reliefs of the four Evangelists in their studies (in the Old Sacristy)

Pair of reliefs of the Medici patron saints (in the Old Sacristy)
Pair of bronze doors, with saints and martyrs (in the Old Sacristy)
Church of Santa Croce
The Cavalcanti Annunciation, pietra serena bas-relief (south aisle)
Crucifix, painted wood statue
Museum of Santa Croce
St. Louis of Toulouse, gilt-bronze statue
Fondazione Salvatore Romano, Piazza Santo Spirito
Pair of fragmentary bishop saints, limestone reliefs with mosaic
Museo Bardini
(After Donatello) The Holy Family, stucco relief
The Madonna dei Cordai, painted wood and gesso relief
The Virgin Adoring the Child, stucco relief
Museo Nazionale, del Bargello
David with the Head of Goliath, marble statue
St. George, marble statue (in plaster copy of the niche on Orsanmichele)
St. George and the Dragon, marble relief (in plaster copy of the niche on Orsanmichele)
David with the Head of Goliath, bronze statue
Amor-Atys, bronze statue
Bust of a youth wearing a cameo, bronze
Bust of Niccolò da Uzzano, painted terracotta
The Heraldic Lion of Florence *(Il Marzocco),* pietra serena statue
The Medici Crucifixion, bronze relief, partly gilt
(Attrib.) Head of a bearded old man, bronze
(Attrib.) Madonna della Ghererdesca, terracotta relief
(After Donatello) Madonna Goretti-Miniati, marble relief
(After Donatello) Madonna Torrigiani, marble relief
Museo di Palazzo Vecchio
Judith and Holofernes, bronze group (modern copy mounted on column in Piazza della Signoria)
Via Pietrapiana (Canto di Nello)
Virgin and Child, terracotta relief

MANTUA
Galleria e Museo del Palazzo Ducale
(After) The Blood of the Redeemer, limestone relief (11539)

NAPLES
Church of Sant'Angelo a Nilo
Tomb of Cardinal Rainaldo Brancacci, esp. the low relief of the Assumption of the Virgin

PADUA
Basilica of St. Anthony (The "Santo")
Crucifix, bronze statue

The Virgin and Child (bronze statue on high altar)
St. Francis (bronze statue on high altar)
St. Anthony of Padua (bronze statue on high altar)
St. Louis of Toulouse (bronze statue on high altar)
St. Prosdocimus (bronze statue on high altar)
St. Daniel (bronze statue on high altar)
St. Justina (bronze statue on high altar)
Four Miracles of St. Anthony (bronze relief on high altar)
Four Symbols of the Evangelists (bronze relief on high altar)
Pietà (bronze relief on high altar)
Twelve musician angels (bronze relief on high altar)
The Entombment, stone relief on back of altar
Museo Antoniano
Architectural fragments of the original high altar
Piazza del Santo
Monument to Erasmo da Narni, called Gattamelata, bronze equestrian figure,
 on stone pedestal

PISA
Museo Nazionale di San Matteo (formerly Church of Santo Stefano)
San Rossore, gilt-bronze reliquary bust

PRATO
Cathedral
External pulpit, marble (original in Museo Diocesano)

ROME
Basilica of St. Peter (Sagrestia dei Beneficiati, now within the museum precinct)
Tabernacle of the Blessed Sacrament, with panel of the Entombment and
 angels, marble relief
Church of Santa Maria in Aracoeli
Tomb slab of Archdeacon Giovanni Crivelli, marble relief

SIENA
Baptistery (on the font)
The Feast of Herod, gilt bronze relief
Putto with trumpet, gilt bronze statuette
Putto dancing, gilt bronze statuette
Faith, gilt bronze statuette
Hope, gilt bronze statuette
Cathedral (north transept)
Giovanni Pecci, Bishop of Grosseto, bronze relief
Museo dell' Opera del Duomo
Virgin and Child with Three Angels, marble relief (modern copy mounted
 over the Porta del Perdono)

Torrita di Siena, Ospedale Maestri
The Blood of the Redeemer, marble lunette relief

VENICE
Church of Santa Maria Gloriosa dei Frari
St. John the Baptist, painted wood statue

United States of America

BOSTON
Museum of Fine Arts
Madonna of the Clouds, marble relief (17.1470)

NEW YORK
The Metropolitan Museum of Art
(Attrib.) Cherub with Shell, bronze ornament

WASHINGTON D.C.
National Gallery of Art
The Virgin and Child before an Arch, gilt bronze plaque (1957.14.131)

Further Reading (in English)

———— § ————

Ames-Lewis, F. "Donatello's Bronze *David* reconsidered." *Art History* 2, no. 2 (1974): 140–55.

———. "Donatello's Bronze *David* and the Palazzo Medici Courtyard," in *Renaissance Studies* 3, no. 3 (1989): pp. 235–51.

Avery, C. "Donatello," in *The Dictionary of Art,* London [in press].

———. "Donatello's *Madonnas* Reconsidered." *Apollo* (1986): 174–82.

———. "Donatello's Marble Narrative Reliefs," in *Atti della Giornata di Studio, Le Vie del Marmo,* Pietrasanta, 3 October 1992 [in press].

———. *Florentine Renaissance Sculpture.* London, 1970.

Balcarres, Lord. *Donatello.* London and New York, 1903.

Bennett, B. A., and D. G. Wilkins. *Donatello.* Oxford, 1984.

Bode, W. *Florentine Sculptors of the Renaissance.* London, 1928.

Cruttwell, M. *Donatello.* London, 1911.

Darr, A. P. "The Donatello Exhibition at Detroit and Florence: Results, Perspectives, and New Directions," in M. Cämmerer, ed. "Donatello Studien." *Italienische Forschungen* 3, no. 16 (1989): pp. 11–23.

Elam, C., et al. "Donatello at Close Range." *Burlington Magazine* 129 (1987): special supplement, after p. 216.

Foster, P. "Donatello Notices in Medici Letters," *Art Bulletin* 62 (1980): 148–50.

Founders' Society. Detroit Institute of Art. *Italian Renaissance Sculpture in the Time of Donatello.* Detroit, 1985.

Goldscheider, L. *Donatello: Complete Phaidon Edition.* London, 1941.

Grassi, L. *All the Sculpture of Donatello.* London, 1964.

Greenhalgh, M. *Donatello and His Sources.* London, 1982.

Hartt, F., and D. Finn. *Donatello, Prophet of Modern Vision.* New York, 1973, and London, 1974.

Janson, H. W. *The Sculpture of Donatello.* Princeton, 1957 (reprint, 1963).

Joannides, P. "Masaccio, Masolino and 'Minor' Sculpture." *Paragone* 38 (1987): pp. 3–24.

Lightbown, R. W. *Donatello and Michelozzo: An Artistic Partnership in the Early Renaissance and Its Patrons*. London, 1980.

Pope-Hennessy, J. assisted by R. Lightbown. *Catalogue of Italian Sculpture in the Victoria and Albert Museum*. London, 1964.

————. *Essays on Italian Sculpture*. London, 1968.

————. *Italian Renaissance Sculpture*. London, 1958 (reprint, 1971).

————. "The Medici Crucifixion of Donatello." *Apollo* (1975): "The Madonna reliefs of Donatello." *Apollo* 1976: (both reprinted in J. Pope-Hennessy, *The Study and Criticism of Italian Sculpture,* Princeton, 1980).

————. *Donatello Sculptor*. New York, London, Paris, 1993. (This book was published too recently for its conclusions to be taken into account in the present work.)

Radcliffe, A., and C. Avery. "The Chellini *Madonna* by Donatello." *Burlington Magazine* (1976): pp. 377–87.

Salmi, M. et al. *Donatello e il suo tempo, Atti dell'VIII Convegno internazionale di studi sul Rinascimento*. Florence, 1966 (reprint, 1968).

Schneider, L., ed. "Essays for Donatello's 600th Birthday." *Source: Notes in the History of Art* 5, no. 3 (1986): pp. 1–32.

Settesoldi, E. *Donatello and the Opera del Duomo*. Florence, 1986.

Sperling, C. M. "Donatello's bronze *David* and the Demands of Medici Politics." *Burlington Magazine* 134, no. 1069 (April 1992): pp. 220–24.

Vasari, G. *Lives of the Artists*. Various editions, originally 1568.

Index

— ◊ —